Chinese Calligraphy

The art of calligraphy is seen as the epitome of Chinese art. Originating in the earliest abstract symbols carved on cave walls, animal bones, and tortoise shells by the ancient Chinese people, over several thousand years calligraphy has become far more than a means of writing and recording events. This book provides an illustrated introduction to the history of calligraphy from the beginning of the Chinese written language, the methods and styles used by calligraphers through the ages, and the influence that calligraphy has had on modern art around the world.

Introductions to Chinese Culture

The thirty volumes in the Introductions to Chinese Culture series provide accessible overviews of particular aspects of Chinese culture written by a noted expert in the field concerned. The topics covered range from architecture to archaeology, from mythology and music to martial arts. Each volume is lavishly illustrated in full color and will appeal to students requiring an introductory survey of the subject, as well as to more general readers.

Chen Tingyou

CHINESE
CALLIGRAPHY

CAMBRIDGE
UNIVERSITY PRESS

CAMBRIDGE UNIVERSITY PRESS
Cambridge, New York, Melbourne, Madrid, Cape Town, Singapore,
São Paulo, Delhi, Dubai, Tokyo, Mexico City

Cambridge University Press
The Edinburgh Building, Cambridge CB2 8RU, UK

Published in the United States of America by Cambridge University Press,
New York

www.cambridge.org
Information on this title: www.cambridge.org/9780521186452

Originally published by China Intercontinental Press as
Chinese Calligraphy (9787508516950) in 2010

© China Intercontinental Press 2010

This updated edition is published by Cambridge University Press
with the permission of China Intercontinental Press under
the China Book International programme .

For more information on the China Book International programme, please visit
http://www.cbi.gov.cn/wisework/content/10005.html

Cambridge University Press retains copyright in its own contributions
to this updated edition

© Cambridge University Press 2011

First published 2011

A catalogue record for this publication is available from the British Library

ISBN 978-0-521-18645-2 Paperback

NOT FOR SALE IN THE PEOPLE'S REPUBLIC OF CHINA (EXCLUDING
HONG KONG SAR, MACAU SAR AND TAIWAN)

Contents

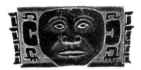

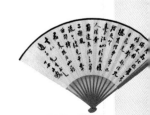

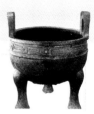

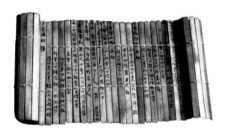

Foreword
A Cultural Treasure of China

C alligraphy is the quintessence of Chinese culture. Throughout the world, a thousand kinds of written language have emerged. Calligraphers strive to make written scripts look beautiful and elegant, using different artistic styles to meet specific needs. The writing of Chinese characters has developed into a highly specialized art. Chinese calligraphy has flourished over several thousand years and, like painting, sculpture, poetry, music, dance and opera, it is an important member of the family of arts.

Practiced by more people in China than any other art, calligraphy can be found everywhere in the country, and is closely linked to daily Chinese life. Billboards with inscriptions by famous figures are often found in shops and shopping centers, brightening up busy trading areas. Calligraphic works also decorate sitting rooms, studies and bedrooms. Chinese characters are usually written on Xuan paper which is good at absorbing ink. The work is then pasted onto thicker paper with a silk edge, and mounted on a scroll or put into a picture frame, to be hung on a wall. Such works usually contain a poem, a pair of couplets, or a proverb. If the calligraphy is written by the home-owner, it may demonstrate their aspirations and interests, or their literary or artistic talent. A calligraphic work can make a plain wall look more interesting.

Spring Festival couplets are calligraphic works designed specifically for the Spring Festival, the most important festival celebrated in China. Written on red paper, the couplets are

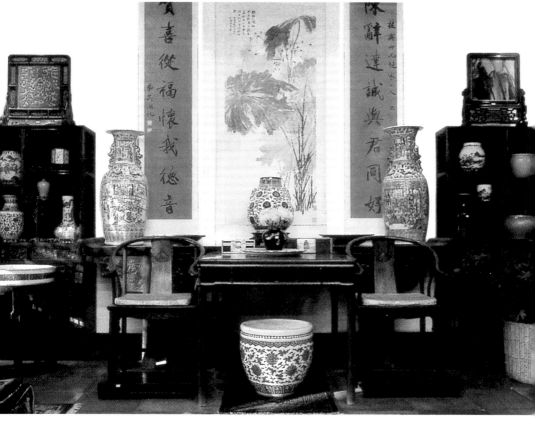

The traditional sitting room of a scholar.

posted on gateposts, door panels, walls or houses. The characters in the couplets express good wishes for the coming year.

Characters in special styles are used for the headlines of newspapers and magazines, and for the titles of books. The six characters on Chinese banknotes, meaning "People's Bank of China," were written by a famous calligrapher. The calligraphic characters or paintings on folded fans are said to reflect the elegance of the user.

The Chinese people have a lifelong bond with calligraphy. A newborn baby's first photo album contains congratulations

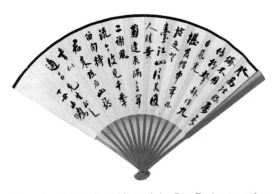

A running-style calligraphic work by Pan Boying on a fan covering.

written by their relatives with a brush and ink. When a couple gets married, their pillowcases are embroidered with "喜喜" (meaning "double happiness") in calligraphic style. On somebody's birthday, a large "寿", meaning "longevity" in calligraphic style, is hung up in their house. After someone's death, the inscription on their tombstone is engraved by a calligrapher.

Tourists visiting China can find calligraphic works in pavilions, towers and buildings, and on wooden boards and rocks. The gate-tower of the Shanhai pass at the eastern end of the Great Wall has a horizontal plaque on its eaves, which is inscribed with five giant Chinese characters meaning "The first pass under Heaven." They were written by the famous calligrapher Xiao Xian of the Ming Dynasty (1368–1644), and compliment the beautiful surrounding scenery.

Visitors to Mount Taishan in Shandong Province can go to the Sutra Stone Valley to the east of Lonquan Peak, and see the text of the Buddhist Diamond Sutra, carved into a 60,000 square meter rock by a calligrapher

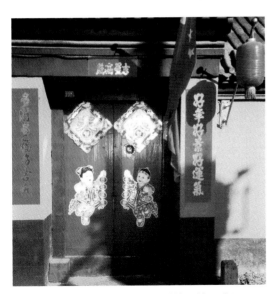

A pair of Spring Festival couplets and New Year pictures on the main gate of a house.

in the sixth century BC. The characters measure between 35 and 50 square centimeters, but only 1,067 of the 3,017 original characters are legible.

In Shaoxing, Zhejiang Province, is the Orchid Pavilion, a Mecca for calligraphers in China. On a spring day in the year 353, Wang Xizhi (306–361 AD), who later became one of China's most distinguished calligraphers, joined forty-one other writers at the Orchid Pavilion to drink wine and compose poems. That day he wrote, in calligraphy, the 324-character *Preface to the Collection of Orchid Pavilion Poems*, for which the Orchid Pavilion is now famous. Xizhi's calligraphy has been hailed as the "first running hand under Heaven." Unfortunately, the original version of the preface

Cliff stone inscriptions
Calligraphy or Buddhist figures carved on cliffs or stones can be seen all over China. Cliff stone inscriptions are traditionally believed to work as a spell to prevent bad luck.

The gate-tower of the Shanhai Pass and the horizontal plaque inscribed with five giant Chinese characters meaning "The First Pass under Heaven."

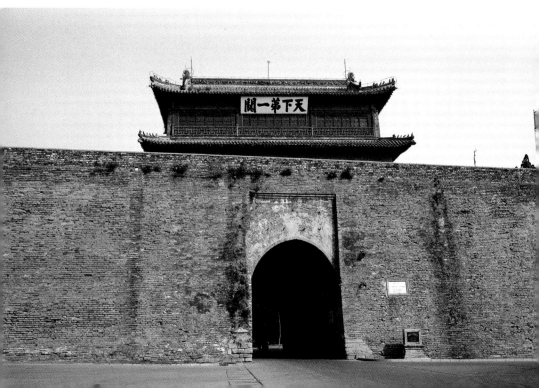

Part of the text of the *Buddhist Diamond Sutra in the Sutra Stone Valley*, from the Northern and Southern Dynasties.

was buried with Li Shimin, the second emperor of the Tang Dynasty (r. 626–249), who was a great admirer of Wang Xizhi and also an accomplished calligrapher. The preface we can see today is a copy produced by Feng Chengsu of the Tang Dynasty.

The Forest of Steles in the ancient capital city of Xi'an is home to the oldest and largest collection of steles in China, and is a treasure trove of ancient Chinese calligraphy, art, classics and stone engraving. More than 2,000 inscribed tablets and tombstones from the Han (306 BC-220 AD) and Tang Dynasties (618–907) are displayed in the exhibition halls, galleries and pavilions. Built in 1087, the Forest of Steles is now the Xi'an Beilin Museum and is a cultural site under state protection.

The criteria for assessing calligraphic skills are rigorous. The skills of a writer demonstrate their cultural background, artistic ability and personality. Through the ages, many of China's famous calligraphers have also been painters, thinkers, politicians or scholars, so it is impossible to talk about a person's achievements in calligraphy without mentioning their contribution to other fields.

Calligraphy is the first art that Chinese people learn. When parents and teachers show children how to read characters, as well as simply showing them the lines and strokes, they also encourage them to develop their creativity and appreciation of the art.

Calligraphy has been called "a painting without images, a piece of music without sounds, a stage without actors and

於可遇羅得於己快然自足不

題舍萬殊静躁不同當其欣

或因寄所託放浪形骸之外雖

一世或取諸懷抱悟言一室之内

娛信可樂也夫人之相與俯仰

所以遊目騁懷足以極視聽之

觀宇宙之大俯察品類之盛

是日也天朗氣清惠風和暢仰

Part of the *Preface to the Collection of Orchid Pavilion Poems*, written by Wang Xizhi of the Jin Dynasty.

永和九年歲在癸丑暮春之初會

于會稽山陰之蘭亭脩禊事

也群賢畢至少長咸集此地

有崇山峻領茂林脩竹又有清流激

湍暎帶左右引以為流觴曲水

列坐其次雖無絲竹管絃之

actresses, and a building without components and materials." Calligraphic works are said to express the essential elements of beauty—balance, proportion, variety, continuity, contrast, movement, change and harmony—through different shapes and line formations. Calligraphy inspires other arts, and vice-versa.

Like music, rhythm is a major element of calligraphy. The dots and strokes in thick or light ink, or in round or square shapes, show strong rhythm, just like change and movement in musical rhythm, expressing the thoughts and emotions of the calligrapher. Theorists of calligraphy describe calligraphic works as "music in the air," or liken it to "a wonderful piece of music played by an excellent musician."

Calligraphic works are also said to convey the

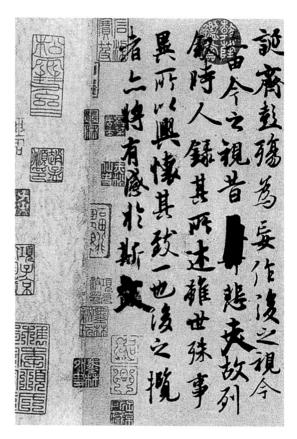

The last part of the *Preface to the Collection of Orchid Pavilion Poems*, written by Wang Xizhi of the Jin Dynasty.

Lu Xun (1881–1936).

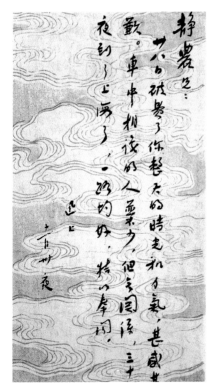

A running-script letter by Lu Xun.
A writer and renowned calligrapher, Lu Xun developed his own simple, smooth style. His works are kept as treasures.

beauty of the body and its movement like the art of dance, as both arts are concerned with space and time. Calligraphy and dance take inspiration from each other. Zhang Xu, a master of cursive-script calligraphy from the Tang Dynasty, was famous for his distinctive rhythms and wild style. Legend has it that his calligraphy was inspired by the "sword dance" (an expressive aerobic dance made famous by the dancer Gongsun during the Tang Dynasty). Through distinctive rhythms and tight movements, this dance expresses various emotions such as joy, sadness, anger, aspiration, demand, bravery and inspiration. The cursive-script calligraphic works of Zhang Xu, the poems by Li Bai (701–762) and the sword dance by General Pei Min were described as "three wonders" by the emperor at that time. The *Four Models of Calligraphy of Classical Poems*, a rare historic work by the calligrapher Zhang Xu, uses bold and unrestrained characters. The characters are linked together as though they are one, and the space between them varies greatly.

In the 1980s, a Beijing TV Station showed an artistic program entitled "Ink Dance," which introduced the arts of calligraphy and dance. A calligraphic work would be presented, and a dancer would then represent it through dance moves, reflecting the shapes and meanings of the characters with light steps, soft waist movements and gentle music.

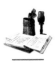

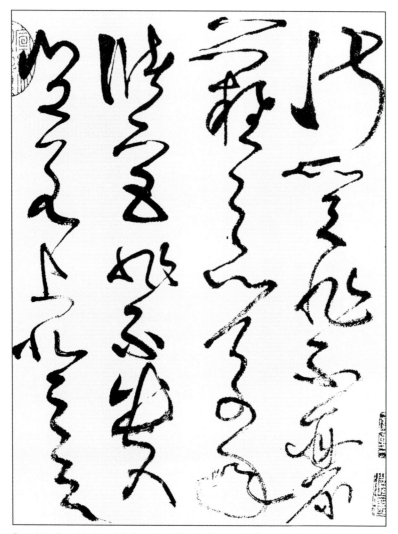

Part of the *Four Models of Calligraphy of Classic Poems*, by Zhang Xu of the Tang Dynasty.

Calligraphy is closely related to traditional Chinese painting. Both arts use brushes and Xuan paper, but are different in that calligraphy uses black ink only, while painting applies lots of colors. In bookstores, calligraphic works are often sold with paintings, and the two are usually displayed together

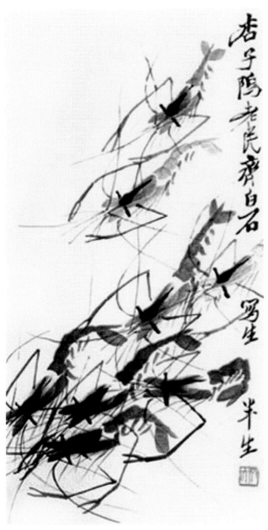

A wash painting, *Shrimp*, by Qi Baishi.

at exhibitions. Painters usually save space in their work for a calligrapher to write a classical poem or some poetic lines related to the subject of the picture. A picture is thought to be more attractive if it is accompanied by a poem composed by the painter. In the past, an artist who was good at poetry, calligraphy and painting was known as "a person with three wonderful talents." China has produced many such people throughout its history.

The skills used in calligraphy and painting are interchangeable. Traditional painting takes its inspiration from calligraphy in its use of brush and ink, particularly in abstract art. Chinese brush painting originated from the simple, smooth brush strokes of calligraphy. Qi Baishi's well-known paintings of shrimps are good examples of this, as they use a few simple strokes and different shades of ink, allowing the water in the stream to be visualized, without actually being drawn.

The leading role of calligraphy in the arts is similar to the role of mathematics amongst the natural sciences. Although mathematical theory is abstract, natural scientists rely on its principles in their work. It is said that this was expressed 2,500 years ago by the philosopher Lao Zi, as "mystery upon mystery—the gateway of the manifold secrets." His words can also be applied to Chinese calligraphy, as artists and enthusiasts see it as something mysterious and profound, which provides a doorway to other kinds of art.

Chinese Characters

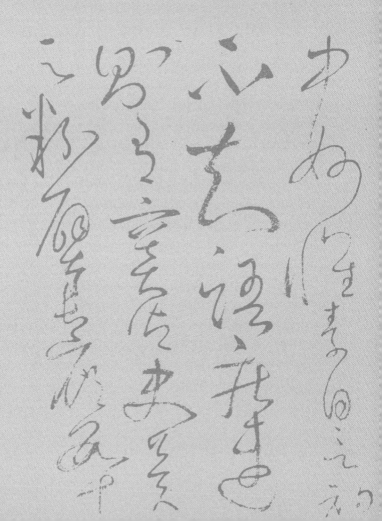

Unique Chinese Characters

This chapter introduces the unique shapes of the characters in Chinese calligraphy. To the art, the shapes are said to be like "water and air," in that they are essential for its existence.

All written language has three key elements: shape, meaning and pronunciation. In Chinese calligraphy, the shapes of the characters are closely related to one-another and the meaning of the character is slightly related to the character itself. However, the character and its pronunciation have no relationship at all.

Chinese characters are square, occupying a square space on the paper. There are a total of 90,000 characters, with 3,500 being the most commonly used, and they are made up of thousands of combinations of shapes.

Chinese characters are generally composed of a dozen basic strokes, which have similar functions to the letters of Western languages. However, unlike Western languages, sounds are not related to syllables. There are eight basic strokes: dot, horizontal stroke, turning stroke, vertical stroke, hook stroke, right-upward stroke, left-downward stroke and right-downward stroke. These are all demonstrated in the character 永 (yong), in the so-called formal script.

The special forms and composition of Chinese characters.
Chinese characters occupy a square space each.

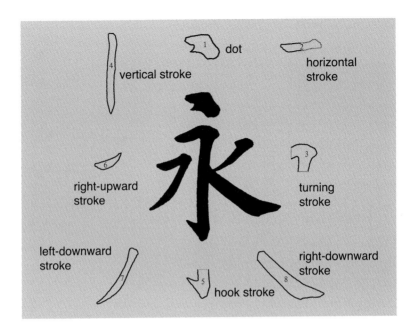

In individual handwriting, and in different styles of script, the strokes vary. For example a dot in the formal script can be written in more than twenty different ways, and the hook stroke in a dozen different ways. Some examples of these are shown on the next page.

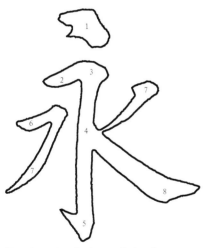

The character 永 demonstrates the eight fundamental strokes. The numbers in the two pictures above show the writing order of the strokes.

In each square space, different strokes are linked and arranged in various ways to create the characters, making them neat and easy to read. The strokes are placed in various positions within the square—upper or lower, left

or right, separate or linked, crossed, continuous, overlapping, piling up or surrounding.

There are more than ten handwriting styles in China, and five different scripts. The first three are commonly used, whereas the other two are archaic and are now only used in calligraphy.

Formal script, or regular style

At more than 1,000 years old, the formal script is a fundamental style of Chinese writing, and is used for printed matter and computerized fonts. Its standard strokes, rigorous rules, and slow writing speed, make it easy to read. This style is commonly used for shop names, billboards on buildings, Spring Festival couplets, tombstones, monuments, newspaper headlines and official documents.

Running script

This style developed as a quick way of writing the formal script, and sits halfway between the formal and cursive scripts. It is looser than the formal script, with more lines between the dots and strokes. Most characters in this style have slanted shapes. All of its strokes are simple, smooth and light, and are easy to

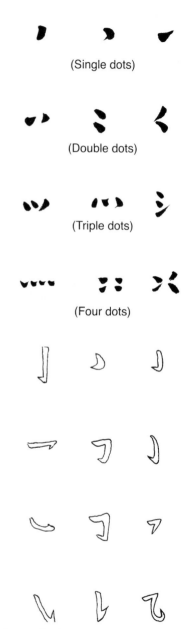

(Single dots)

(Double dots)

(Triple dots)

(Four dots)

Dots and hook strokes in different forms.

recognize. This style is typical of everyday writing, such as that used in correspondence.

Cursive script

Written at the highest speed, the form of the characters in this style is much less like the formal script. The characters are irregular, with some strokes joining together, and parts of strokes or whole strokes sometimes omitted. This makes the characters more difficult to read.

Seal script

This is the most ancient calligraphic style, and is only used occasionally to create special effects. Its ancient stamp-script characters were discovered in inscriptions carved on oracle bones (animal bones and tortoise shells used for divination) and on ancient bronze objects. It contains few strokes, with no dots, hooks or turning strokes, and the lines are consistently thick, symmetrical, and evenly distributed. Although people today find the characters very difficult to read, they are seen to be full of mystery and charm. Stamp-script calligraphic work helps us

Characters are composed of strokes arranged in different ways.

to understand the sentiments of China's earliest artists, and its ancient culture.

Official script

This basic form appeared after the seal script, and was popular during the Han Dynasty (206 BC-220 AD). Official script differed from seal script because strokes were no longer drawn in an even thickness, and the pictographic and ideographic features of seal script were largely diminished or lost. Its characters are also much wider than the long shapes of the other four scripts. Although this script is ancient, it is very easy to read.

The characters that we see in print today are those known as Song, imitation-Song, block and boldface. The Song style was developed during the Song Dynasty (960–1276) when moveable-type printing was invented, and was used by the calligraphers Ouyang Xun and his son Ouyang Tong in the Tang Dynasty (618–907). It was reformed during the Ming Dynasty

入法界體性經

等聞佛所說皆大歡喜

及餘諸比丘并諸天眾犍闥婆人阿修羅

師利童子及餘菩薩摩訶薩上座舍利弗

說法義當得不斷辯十佛說此經時文殊

忍若為生他善根若少讀誦已而能為他

Part of the formal-script *Buddhist Sutra* by Liu Yong of the Qing Dynasty.
Liu Yong (1720–1805) was a grand academician and one of the great four calligraphers of the Qing Dynasty.

筆扇半陷以間者之

安丘沈五龍家當有者

國戲筆國戲筆常嘗点于今亦

作花葉顆一般握丟曲者

瓊釈手教琵琶诗癸长

國抱崢暮月言歌之偈

樣

奉命诸所畫万面勾诗同脱

近士而以府七司之外无尤枋家于

正

為了敢也附

Giant characters in the running script by Bada Shanren, or Zhu Da, a monk painter from the Qing Dynasty.

書

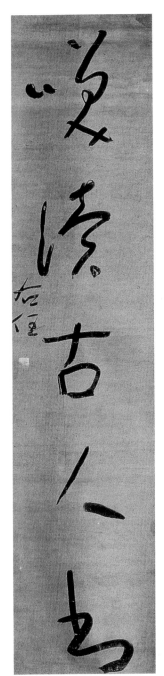
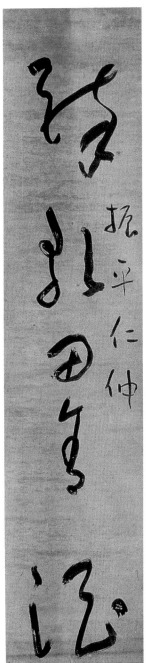

A pair of couplets in the running
script by Yu Youren.
Yu Youren (1879–1964) was a
master poet and calligrapher,
particularly in the running script. His
Standard Running Script has been
highly acclaimed by calligraphers.

Seal-script characters engraved on drum-shaped stones by Wu Changshuo.
Wu Changshuo (1844–1927) was accomplished at calligraphy, painting and carving in the seal script style. He was a respected teacher and poet.

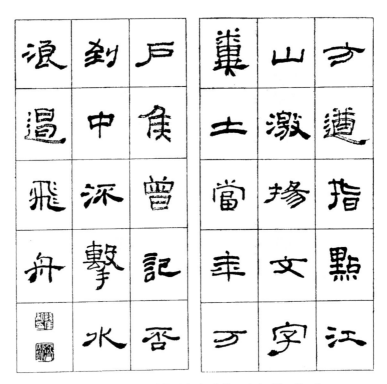

Pages from the *Book of Models of Official-Script Calligraphy* by Qian Shoutie.
Qian Shoutie (1897–1967) was skilled in all kinds of calligraphic scripts. He was a student of the leading calligrapher and painter Wu Changshuo. Qian's paintings are generally of mountains and rivers.

Commonly used styles for prints and computer scripts include the Song, imitation-Song, formal, running-formal, Shu, boldface, Wei tablet and official styles.

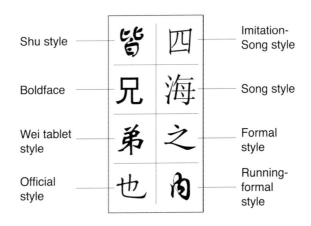

Shu style

Boldface

Wei tablet style

Official style

Imitation-Song style

Song style

Formal style

Running-formal style

(1368–1644), with thicker vertical strokes and thinner horizontal strokes, and has been the main style used in printing since the sixteenth century. In the imitation-Song style, all of the strokes are thin. The block style is a printing style which looks very similar to handwriting. More recently, some other block characters have been used in print and computer formats, such as the Shu style, which we can see in the work of modern calligrapher Shu Tong (1906–1998).

Cang Jie.
According to legend, Cang Jie was the Grand Historiographer during the reign of the Yellow Emperor, and created Chinese characters.

Oracle Bone Inscriptions and Inscriptions on Bronze Objects

It is difficult to ascertain the exact period in which Chinese characters originated. Their embryo may be in the geometric designs on the 5,000–7,000 year-old pottery of the Yangshao Culture, found in Yangshao village in the 1920s. The next 2,000–3,000 years is a blank period in our knowledge of the characters' development, as no cultural relics from that period with traces of writing on them have yet been found.

The inscriptions found on oracle bones and ancient bronze objects from the Shang Dynasty (1600–1046 BC), over 3,000 years ago, are the earliest systematized Chinese characters.

Oracle bone inscriptions

The earliest written characters discovered so far, are in the form of divinations and prayers to the gods inscribed on animal bones and tortoiseshells.

In the autumn of 1899, the Beijing official Wang Yirong (1845–1900) fell ill with malaria, and his

Yangshao Culture
Yangshao Culture is a culture of Neolithic New Stone Age, from 5,000 to 7,000 years ago. It was first discovered in Yangshao Village of Mianchi County in Sanmenxia City, Henan Province in 1921. Yangshao Culture is mainly found in the midstream and downstream areas of the Yellow River, in the western part of the Henan Province, the basin of the Weihe River in Shaanxi Province, and in the southwestern part of the Shanxi Province. It also reaches the middle of the Hebei Province in the east, the midstream and upstream of the Han River in the south, the basin of Taohe River in the Gansu Province in the west, and the Hetao area of Inner Mongolia in the north. Hundreds of cultural relics and remains have been exhumed in those areas. The Yangshao Culture period is also known as the most glorious period for painted pottery during the Neolithic Age in China.

doctor prescribed him a medicine known as "dragon bone." He bought this from a pharmacy and found some markings on the bone, which looked like ancient forms of Chinese characters. So he bought more of them, and consulted his friend Liu E (1857–1909), an expert on ancient Chinese script, who agreed that the markings were probably ancient characters.

Wang later traced the origins of the bones to Xiaotun Village in the Northwest of Anyang, Henan Province, the last capital of the Shang Dynasty.

If Wang had not fallen ill, if he had not been well-versed in the ancient Chinese language, and if his doctor had not prescribed him the dragon bones, these antique characters which have been so central to research into the origins of Chinese civilization, might never have been discovered.

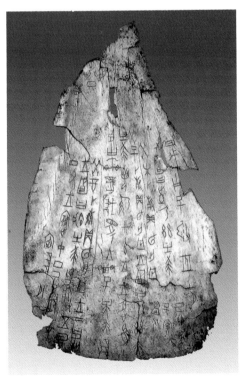

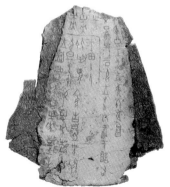

Inscriptions on oracle shells and bones.

Wang Yirong was not only an official of the Qing Dynasty; he was also the governor of the Shanxi Province and a prominent patriot. When the Sino-Japanese war broke out in 1894, he asked the emperor for permission to go back to his native home in Shandong, and raise an army against the invaders. But the Qing government reached a treaty with the Japanese invaders, which humiliated the Chinese people and forfeited their sovereignty. In August 1900, when the Eight-Nation Alliance invaded Beijing, Wang was appointed as a minister in charge of training the armed forces in the metropolitan area.

While Beijing was occupied by the invaders, Wang wrote his last words in the formal script, stating his loyalty to the emperor. Then he drowned himself in a

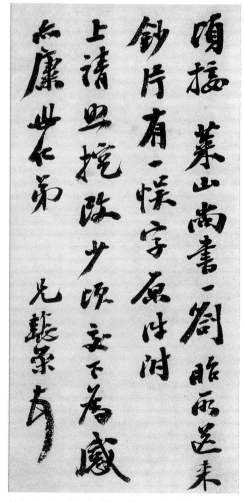

A short note written by Wang Yirong of the Qing Dynasty.

well, along with his wife and eldest daughter-in-law. This was less than a year after he had found the oracle bone inscriptions, and he left no record of his research.

The earliest book on oracle bone inscriptions, *Tortoise Shells Preserved by Tieyun*, was written by Liu E, and published in 1903. In the book he identifies more than forty characters on

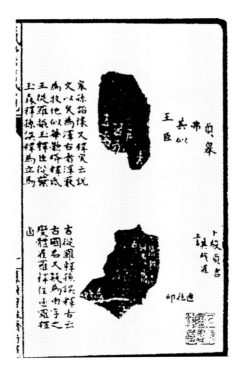

The first page of Liu E's book *Tortoise Shells Preserved by Tieyun*.
Liu E was a pioneering writer of the late Qing Dynasty. He is famous for *The Travels of Lao Can* and *Tortoise Shells Preserved by Tieyun*. The latter deals with his research into inscriptions on tortoise shells. *Tieyun* is Liu's assumed variant name.

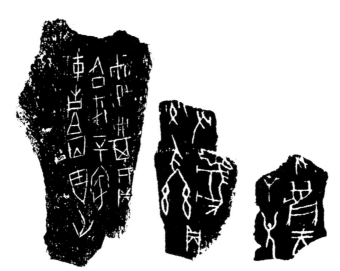

Some inscriptions on tortoiseshells illustrated in Liu E's book *Tortoise Shells Preserved by Tieyun*.

some 3,000 pieces of tortoise shell that he collected, and these were later confirmed by another expert. Liu was the first to certify that the oracle bone inscriptions are Chinese characters. He further attested that these inscriptions dated from the same period as the inscriptions found on bronze vessels produced during the Shang dynasty (1600–1046 BC). While Egyptian hieroglyphics, Mayan script and Sumerian cuneiform script existed during the same period, these scripts all later became extinct. Modern Chinese characters, however, are the direct ancestors of these ancient oracle bone inscriptions.

From some 4,700 characters appearing on the 100,000 pieces of tortoise shell discovered so far, 1,800 have been identified. These inscriptions have provided a great deal of information about the political system, agriculture, animal husbandry, astronomical phenomena, warfare and other aspects of the Shang period. They are also invaluable to the study of calligraphy. Each character on the tortoise shells

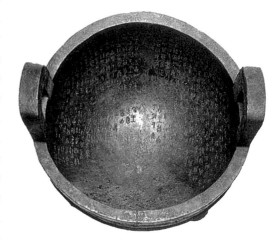

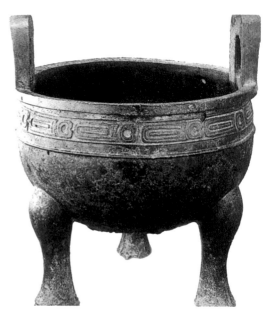

Maogong three-legged caldron.
Produced in the early Zhou Dynasty, it was discovered in the mid-nineteenth century in Qishan County, Shaanxi Province. It demonstrates skilled craftmanship, and the inscriptions engraved on its base have a graceful nature.

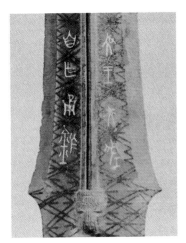

Sword of King Wu of the Spring and Autumn period, bearing eight characters.

A rubbing of part of the *Taishan Mountain Inscription* of the Qin Dynasty.

occupies a square space, engraved from top to bottom and from left to right, just as they are written today, more than 3,000 years on. It is also clear from the inscriptions that symmetrical aesthetics were important to the engravers.

Inscriptions on bronze objects

The inscriptions on bronze objects, such as cooking utensils, wine sets, water containers, weaponry, musical instruments and mirrors, run from one or two characters to several hundred. There are around 3,000 different characters in total, 2,000 of which have been interpreted. These characters are more standard, regular and orderly than those found on bones and tortoise shells.

During the Warring States Period (475–221 BC) of the late Zhou Dynasty, many of the states simplified the strokes of the stamp-script characters in their own ways, which helped develop the various kinds of "big-stamp" style. These were different from the lesser-stamp styles mentioned below.

When the Qin Dynasty (221–206 BC) first united China under Emperor Qin Shi Huang, he ordered the various scripts to be standardized. Based on the characters used in this period, the resulting script became known as the "lesser-stamp-style," which has a more abstract quality. Like the big-stamp style, the strokes of the

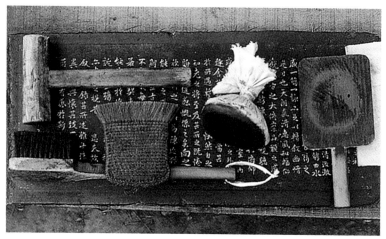

Rubbing tools
Rubbing tools on a rubbing of a calligraphic work, which demonstrates characters in white against a black background.

lesser-stamp style are thick, and there is no difference between right-upward strokes and left-downward strokes. However, the strokes are more even and symmetrical than those of the big-stamp hand.

Li Si (? -208 BC), a Qin Prime Minister and the first calligrapher in recorded Chinese history, initiated the lesser-stamp hand. His striking calligraphic works are seen as models of this style.

A famous example of Li Si's calligraphy can be found in the Andai Temple of Tai'an City, at the foot of Mount Tai in the Shandong Province. There were originally more than 200 characters inscribed on a tablet erected at the top of the mountain, but only nine can still be read today. What is displayed here is a rubbing of the remaining part of the tablet. Rubbings are made by covering the inscriptions on stone or bronze with a piece of moist paper, and pressing onto it a wad of silk, stuffed with cotton and soaked with ink. This makes the characters stand out in white against the black

ink background. Many of the illustrations in this book show rubbings from original inscriptions.

Official Script and Later Scripts

During the Qin Dynasty it was important for information to be exchanged quickly between local and central governments in various parts of the country. This demanded the fast writing of documents and notices, with little attention to the length and thickness of the strokes. People also tended to prefer inconsistent and uneven characters to even, symmetrical ones, and as a result the cursive and cursive-stamp hand emerged.

The cursive-stamp hand is quite different from the cursive hand, the official hand and the lesser-stamp hand. It later took on more features of the standard official hand, and became known as the ancient official hand.

Ancient official-script characters written on silk, from the Han Dynasty, discovered in Mawangdui, Changsha, Hunan Province, in 1973.

The demise of the stamp hand saw more and more calligraphers breaking the rules of consistency in the thickness and length of the strokes. Some deliberately extended the vertical strokes and hook strokes, or exaggerated the right-downward strokes. Some started writing characters in a new way, starting the strokes with a depiction of a silkworm's head and ending them with a depiction of a wild goose's tail. This style was gradually adopted by most calligraphers, and finally developed into the official script, which looked quite different from the ancient official script. The inscription on the "Shichen Tablet" is a typical example of this hand.

宗有罷癃咎寍人
上廣對鄉吏越未辭
廣對質衣僮吏前鄉

下不敢童父母所致也郡國易然臣廣顧歸王杖沒入為官□

臣廣昧死再拜以聞

制曰問何鄉吏論棄市女須時廣見王杖毋故

御史丞□以上枚王杖比大百石入官府不趨吏民有敺辱者逢求道

元□三年□月王申下

棄市令在廟堂甬卅二

汝南郡男子王安世坐桀黠敺鳩杖王折傷興杖棄市南郡房

司馬護坐檀名鳩杖王毀留棄市長免東鄉嗇夫田宣坐敺

鳩丈王男子金里告之棄隴西男子張湯坐桀黠敺王杖王折

Part of the *Shichen Tablet*, dating from the Eastern Han Dynasty.

The official hand was developed in the Eastern Han Dynasty (25–220) and was the second-generation basic calligraphic style to evolve after the stamp style.

The evolution of calligraphy from the stamp hand to the official script, was a mystery until the turn of the twentieth century. Until then, the 2,000–3,000 year interval between pictographs and inscriptions on tortoise shells and bronze objects was a blank period in our knowledge of the development of Chinese writing.

Then, in the 1890s and 1900s, inscriptions on a total of 100,000 bamboo strips dating from the Qin and Han Dynasties, were discovered in Xinjiang, Inner Mongolia, Gansu, Qinghai, Hunan, Hubei, Shandong and Henan. Their inscriptions are written in the ancient official style, which looks very different from the official style of the Eastern Han Dynasty found on stone steles. These were proven to represent a transitional form of writing between the stamp and official styles.

A horizontal stroke in the official hand starts with a "silkworm's head" and ends in a "wild goose's tail."

Ancient official-script characters on bamboo strips from the Han Dynasty, discovered in Wuwei, Gansu Province, in 1959.

After the official style, calligraphers sought a simpler and more elegant style, discarding the horizontal strokes which started with a "silkworm's head" and ended with a "wild goose's tail," and creating the cursive style. Simple and smooth, the strokes of the characters written in the cursive hand are not linked but remain separate. This style is called the Zhang cursive hand, and was fashionable in the third and fourth centuries, but has not been popular since then.

After the Zhang cursive hand, came the Jing cursive hand, although the latter developed from the ancient official style, rather than from the Zhang cursive hand. Characters in the Zhang cursive style are independent from one-another, while those of the Jing cursive hand are linked together.

The running hand is another script which developed after the official hand, and was commonly used in letters and documents. It is easy to read, simple and flexible to use. During its development, it took on elements of both the formal and cursive styles.

Alongside these new calligraphic styles, the formal script emerged. People found it difficult to follow the thick horizontal strokes of the official script, which started

Ode on Sending Out the Troops in Zhang cursive script, written by Suo Jing of the Jin Dynasty.

with a silkworm's head and ended with a wild goose's tail, so they created the formal hand by adopting some strokes from the cursive hand. Initiated during the Han Dynasty, the formal hand came to be commonly used during the early Tang Dynasty. It became a basic calligraphic style of the third generation and was used for the next 1,300 years.

Based on the official style and other new styles mentioned above, some other styles also emerged, such as the running-cursive hand, the formal-running hand and the wild cursive hand.

Next came simplified Chinese characters. Nearly half a century ago, for ease of reading and writing, the government made the simplified characters mandatory in daily writing and typesetting. In simplified Chinese, there is just one way of writing each character, rather than a number of possible ways. Typesetting is horizontal, from left to right, and the lines run from top to bottom. However, most calligraphic writing still features the traditional arrangement of right-to-left and top-to-bottom.

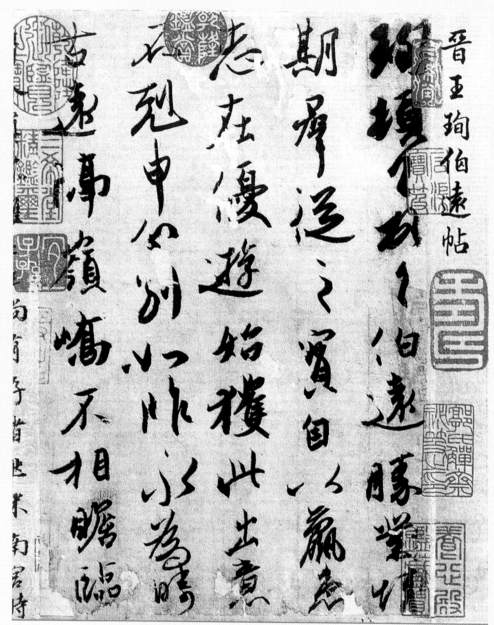

Boyuan Copybook in the running-cursive hand, written by Wang Xun of the Jin Dynasty.
Wang Xun (350–401) was the director of the imperial secretariat and a distant relative of Wang Xizi. Wang was famous for his essays and calligraphic works, and was acclaimed for his mastery of the cursive script. This calligraphic model has 47 characters. Together with the *Copybook of a Sunny Day after a Pleasant Snow* by Wang Xizi and *Copybook on Mid-Autumn Festival* by Wang Xianzi, it was listed as one of the three rare calligraphic models kept in the Sanxi Studio by the Qing Emperor Qianlong.

Four Treasures of the Study

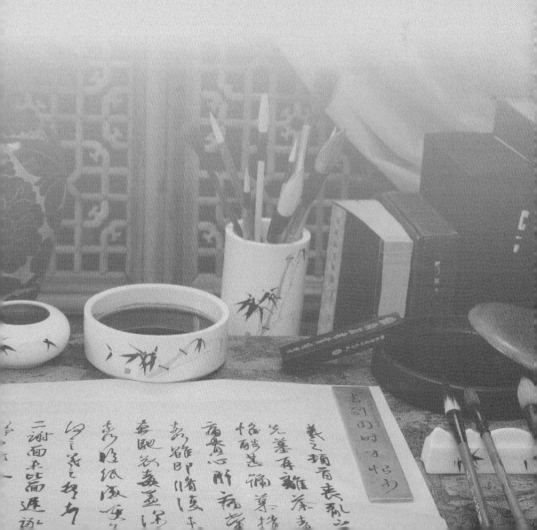

Traditionally, calligraphers keep brushes, paper, ink sticks and ink stones in their studies. Known as the "four treasures of the study," these have objects been essential to the development of calligraphic art.

Brush

The Chinese writing brush can be made from goat hair, rabbit hair, or the tail hairs of a yellow weasel. It is soft and flexible, and when soaked in ink, has what is known as "capillarity," that is, it enables the ink to flow evenly through the hairs onto the paper.

The use of the Chinese writing brush can be traced back 6,000 years. The pictures, symbols and characters on ancient pottery, painted in red and black, look as though they were created with brush strokes. The oldest brush existing today was found in

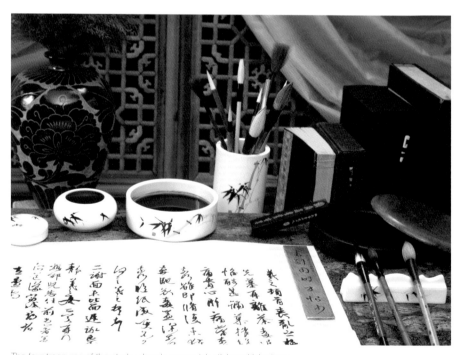

The four treasures of the study—brush, paper, ink stick and ink stone.

1958, inside a fifth-century BC tomb in the State of Chu. A large number of inscriptions on bamboo strips were also unearthed at that time.

In the fourth century, great progress was made in the craft of brush-making, resulting in a brush which allowed calligraphers to reach their full potential. It had four features. First, the tip of the brush meant that the delicate changes of the strokes could be clearly displayed. Second, its smooth end-hair could spread across the paper to create vigorous writing. Third, the brush's cone shape made it easy to move it in all directions on the paper. Fourth, it was durable, keeping its elasticity and softness for a long time. The brush enabled calligraphers to write characters in different shapes, showing different intensities and rhythms. Different thicknesses of ink were also used, which helped to make the characters three-dimensional.

The brushes from the Anhui, Jiangsu, and Jiangxi provinces in the south, and the Henan province in the north, are the most famous in the country. The biggest was made by a factory in Tianjin in 1979. It is 157cm long including its 20cm long hair tip, weighs 5kg, and can soak up 1kg of ink. On September 14, 1979, the calligrapher Yang Xuanting from Beijing used this brush to write four characters meaning "Long Live the Motherland," on a piece of Xuan paper 100cm wide and 150cm long, in celebration of the thirtieth anniversary of the People's Republic of China. In 1990, during the Beijing Asian Games, Yang completed a larger calligraphic work with an even bigger brush.

In ancient times, brushes were made of newborn babies' hair. Over 1,400 years ago, an old woman from southern China invented a brush with a newborn's hair on the inside, and rabbit hair on the outside. It is said that this was a favorite brush of Xiao Ziyun, a famous calligrapher of that time. Even today, some people ask brush manufacturers to make a brush out of their newborn baby's hair. Rather than using it, they

keep it as souvenir, hoping that it will inspire the child as they grow up.

Paper

Paper, the compass, gunpowder, and printing are seen as the four great inventions of China. Paper is said to have been invented by Cai Lun (?-121) of the Eastern Han Dynasty (25–220). Indeed, *The History of the Later Han Dynasty* explains the technique of early paper making. However, in the second half of the twentieth century, ancient paper was discovered in the Shaanzi and Gansu provinces. This suggested that during the Western Han Dynasty (206 BC-25 AD), going back even further than the Eastern Han Dynasty, paper made out of plant fiber was already being used.

Paper used for calligraphy.
On the paper are two seals and a case of red ink paste used for seals.

After Cai Lun died, his disciple Kong Dan tried to make some durable paper on which to draw a

A roll of calligraphy.

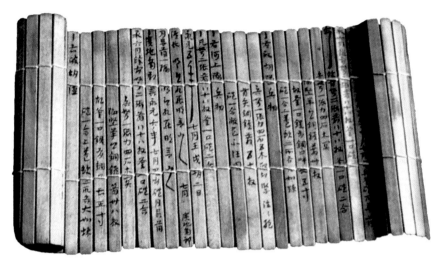

China's earliest bamboo strip book.

memorial picture of him. After failing several times, he finally made some using the bark of a dead tree, which turned out to be the most durable.

Today, the paper most used by calligraphers and painters is Xuan paper from Xuancheng and Jingxian in the Anhui Province. It is made from the bark of the wingceltis tree, and rice straw. After being treated with lime and bleached in the sun, the fibers are made into pulp. Xuan paper is white, delicate, soft, strong, resistant to insects, and retains color for a long time. Because it is so absorbent, the ink placed on it can have a variety of appearances. If a brush soaked in watery ink moves quickly, the stroke will be dark in the center, and the ink around it will be lighter. If a brush soaked in thick ink moves quickly, there will be some white streaks in the stroke, which give the effect of a waterfall. This makes the work look interesting and diverse.

China ink

A special, traditional ink is used for producing calligraphic work and paintings. It is made by rubbing a rectangular or round ink stick onto an ink stone with a little water. The ink stick is made of Tung oil, coal or pine wood soot, animal glue and perfume. It is viscous, cannot fade, and does not congeal into lumps, meaning that calligraphic works created hundreds of years ago still look new today. Although the ink is black,

Ink sticks.

it can be used in different ways to make the strokes thick, thin, dark, light, dry, wet, dull and bright, and take on different hues.

The use of ink can be traced back to the New Stone Age, some 6,000–7,000 years ago. Pottery found in the New Stone Age village of Bampo, Xi'an, had inscriptions on it in charcoal ink.

Most people today use bottled ink for convenience, but many calligraphers still use traditional ink sticks, because they enjoy, and are inspired by, the process of grinding the ink.

After the Jin Dynasty (265–420), calligraphers added their names and stamps to their work, and in the Song Dynasty they started to add other tokens of their aesthetic interests. Collectors would also put their own stamps onto the calligraphic works they collected. Some works have passed through the hands of dozens of collectors, and have been stamped dozens of times.

Ink stone

Ink stones appeared in the third or fourth century, and were similar to devices invented earlier for rubbing dyes. The earliest rubbing device surviving today is around 6,000–7,000 years old. There are many ink stones dating back to the third century, suggesting that they were widely used at that time. They show skilled craftmanship, and some are shaped like a turtle or a stringed instrument. Ancient ink stones are very popular with collectors today.

Most ink stones are made of stone, but some are made of porcelain, pottery, bronze and iron. There is also an ingenious ink stone made of jade. It is transparent and delicate, and the ink rubbed into it cannot freeze, even in the coldest weather. Other famous ink stones include the Lu ink stone from the Shandong Province, the Duan ink stone from the Guandong Provicnce, the She ink stone from the Anhui Province, and the Tao ink stone from the Gansu Province.

Glazed pottery ink slab used by a Tang princess, unearthed in Luoyang.

Beauty of Calligraphy

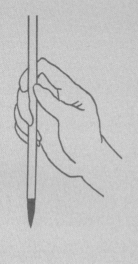

Beauty of the strokes

Ge Typeface
Ge refers to the highest official academic institution in ancient times—Hanlin Academy, or the Imperial Academy. As the officials of Hanlin Academy wrote in a legible but rigid, mechanical manner, "Ge Typeface" is thought to have little artistic merit.

Characters and writing are two essential elements of calligraphy. It is said that if characters are the body of calligraphy, then writing is the soul.

Calligraphic characters are quite different from artistic fonts written purely for decoration. They are also different from those that appear in ancient or modern books. The lines and individual characters of calligraphy are bold and convey emotion. They also create a moving, progressive and rhythmical effect.

We will now discuss three structural forms of calligraphy—strokes, characters and lines, which come together to form what the Chinese see as the beauty of calligraphy.

Strokes are the foundation of the three forms, because the characters and lines are composed of them, and track their movements. Their key elements are rigor, rhythm, change and harmony.

When using a brush, the "vigor" of the strokes is important. The nineteenth-century scholar Liang Qichao (1873–1929) emphasized that "the vigor of the strokes is the main criterion for judging whether a work is good or not."

Sun Guoting (648–703), a calligraphy critic from the Tang Dynasty, said that calligraphy has taught us to have integrity, and that "The charm of calligraphy lies in the strength of the characters." By "strength of the characters" he meant that the energy exerted through using the brush is displayed in the dots and strokes on the paper. Simply dropping ink blots onto the paper does not demonstrate strength at all, and dragging the brush across the paper would just be like covering the paper with paint. When characters are written with a brush, the brush should be held vertically at 90 degrees to the paper's surface.

Returning again to the importance of "the four treasures of the study," characters written with a brush are different to those

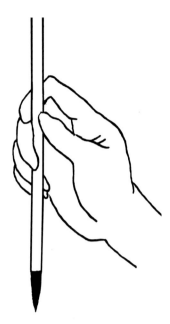

How the brush should be held.

Main hair and secondary hair
Main hair refers to the cluster of long hairs in the middle of the writing brush's head, accounting for 1/6 of the brush's hairs. The secondary hair refers to the hairs which are set next to the main hair, accounting for 2/3 of the hairs.

written with a pen. Strokes created with a pen have roughly the same thickness, whereas those created with a brush have different thicknesses, reflecting dark or light ink, and the speed of the brush's movement. The main difficulty in using a brush, and also one of the features that makes calligraphy unique, is that once the dots and strokes of each character are finished, they cannot be changed. The vigor of the strokes therefore depends on the calligrapher's mastery of the brush.

There are several ways to demonstrate the vigor of the strokes.

One is the use of the tip of the brush. When a character is written, the brush is held vertically and moves from the middle of the stroke. A character written this way is smooth and natural. The opposite of this is the use of the side of the brush, when the tip of the brush moves along one side of the stroke.

A calligrapher also needs to master the technique of pressing and lifting the brush. These are the main ways of expressing rhythm in calligraphy. Lifting the brush a little makes the strokes delicate and smooth, and pressing down on the brush makes the strokes thick and dramatic.

The thickness or thinness and darkness or lightness of the strokes depends on the lifting and pressing of the brush. "大", as written in the formal script, is an example.

While lifting or pressing the brush, a good calligrapher also applies two other skills:

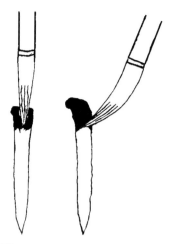

Different ways of using the tip of a brush
in writing a vertical stroke.
Moving the tip of the brush in the middle of
a stroke (left); Moving the side of the tip of
the brush along one side of a stroke (right).

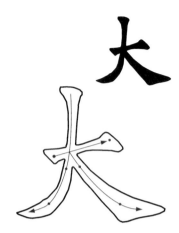

Lifting and pressing.
The red spots show where the brush
should be pressed, and the arrow
shows the direction of the movement of
the brush.

moving the brush forward and holding it in position for a while, or moving it slowly. Just like a basketball player who moves forward while bouncing the ball on the ground, mastering this skill takes a lot of practice.

The various scripts differ in how frequently the brush is lifted and pressed. The wild cursive hand features swift brush movements and fewer changes between lifting and pressing. The changes are more frequent in the lesser cursive and running styles. In the official script there is more variation between lifting and pressing, especially in horizontal strokes (those which start with a "silkworm's head" and end with a "wild goose's tail") and in right-downward strokes. The formal script has the highest frequency of changes in lifting and pressing, but the seal script has no lifting or pressing at all. In the seal script the calligrapher uses just the tip of the brush, not the side, so that each stroke has the same thickness. The vigor of

Copybook of the seal script by Qian Dian of the Qing Dynasty.

strokes in the seal script is created by quick and slow brush movements, along with the application of heavy or dry ink. The firm, smooth characters in the copybook compiled by Qian Sian (1741–1806), a Qing Dynasty master of the seal script, are examples of this. In his later years, Qian Dian suffered from paralysis of his right side, but still created impressive calligraphic works using his left hand.

Beauty of composition

Each stroke has its own individual characteristics, but the full effect is only created when the strokes come together to form a character, or a whole calligraphic work.

In terms of structure, Chinese characters fall into two categories: single and compound characters.

Square characters with four edges.

Single characters.

Composed of left and right parts

Composed of top and bottom parts

Composed of left, middle and right parts

Composed of top, middle and bottom parts

Composed of one part on the top and two parts on the bottom

Composed of two parts on the top and one part on the bottom

Encircled character

Semi-encircled character

Compound characters.

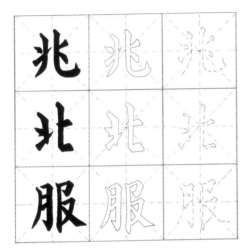

A 米-shaped copy book.

A single character has only one structure, while a compound character can be formed of two structures (left and right, or above and below each other), three single characters (on the left, middle and right, or top, middle and bottom), or encircled characters (full or semi-circled).

All characters have a center or a core. If a calligrapher has a grasp of the center of a character, he can easily arrange the strokes so that they are not too loose or too tight, and do not contrast too much with the other strokes. A range of copybooks have been published to help students with this technique. One of them is a "米"-shaped copybook, in which each square contains four crossed lines, showing how the strokes should move towards and away from the center of the square.

To achieve the best form, the calligrapher must be able to satisfy five requirements:

Straightness and Evenness

To the calligrapher, beauty means evenness and balance, so the strokes should be of equal length, and darkness and brightness

should be used evenly. This is likened to aesthetic beauty in other areas: people with regular features are seen to be attractive, rooms look good if they are tidy and orderly; pictures look best if they are hung in the centre of a wall, and a stamp looks neater on an envelope if it is straight.

The character 三 in seal hand.

Balance

The characters should also be well-balanced, meaning that in those characters with fewer strokes the strokes should be thicker, and in characters with more strokes, the strokes should be thinner and closer together. The seal script is the most balanced script, because it minimizes the blank spaces between characters. The official script, the formal script, and the running script are the next most balanced. The least balanced scripts are the cursive and wild cursive scripts. These place little importance on balance, as they seek to be vivid and rhythmic.

The character 三 in official hand.

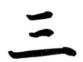

The character 三 in formal hand.

Irregularity

Irregularity is also viewed as a sign of beauty in calligraphy, just as it is in nature. Balanced and even strokes are more typical of printed characters than artistic ones. Even the seal script shows irregular strokes; for example in the character "三", although the three strokes are the same length, the middle one turns upwards at the end. In the official script, the top two strokes are the same length, but the last stroke starts with the "silkworm's head," and ends with the "wild goose's tail." In the formal hand, the top stroke has an upturned end, the middle stroke is short, and the bottom stroke is thicker.

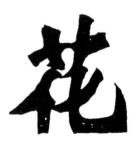

The character 花 (meaning flower).

Part of the *Preface to the Poem on the Pavilion of Prince Teng*, written by Wen Zhengming of the Ming Dynasty. Wen Zhengming, a famous calligrapher and painter of the Ming Dynasty, is well known for his graceful small characters, and vigorous and dynamic large characters.

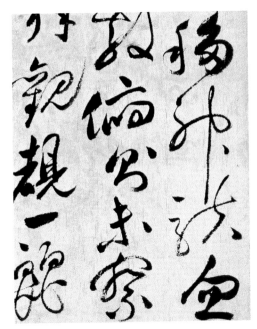

Part of *On the Goddess of the Luo River*, written by Zhu Yunming of the Ming Dynasty.

Coherence

The strokes and the various parts of a character are all supposed to match each other, to make the character as a whole look vivid and rhythmic.

There are two types of coherence in calligraphy—direct and indirect. The character "花" is an example of indirect coherence, because it is composed of four separate parts written with separate, unconnected strokes. When it is written, the four parts should be close, with the top and bottom parts connected.

Direct coherence is generally achieved by two strokes being connected, as in the cursive and running hands. For example, a dot is written as a hook or a turning stroke in order to join it up with the next or previous stroke. A horizontal, left-falling or vertical stroke is written in such a way that it connects with the next or previous stroke.

Movement

Movement is the most effective way of making a character vivid, and is said to bring vitality

and rhythm to an artistic work. There are two ways of creating movement.

First, the speed of the strokes. In the seal and official scripts, a character takes one or two minutes to write, but in the cursive and running hands the brush is moved more quickly, and a character can be finished in seconds. Second, movement can be achieved by slanting the characters, making them look unstable and inconsistent. In the rigorous official hand, the characters can either be straight or slanting and of varying lengths in order to create vividness and rhythm. In the running, cursive and wild cursive hands, this is not possible. *Ode to the Goddess of the Luo River*, by Zhu Yunming (1420–1526), of the Ming Dynasty, is a good example of coherent and dynamic strokes being used in the cursive hand, and shows Zhu's skill in controlling the speed and rhythm of the brush. Zhu, Wen Zhengming (1470–1559), Tang Bohu (1470–1523) and Xu Zhenqing (1479–1511) were four skilled calligraphers from the Suzhou area, and their work played a significant role in the development of calligraphy during the Ming Dynasty.

Beauty of Integration

The term *bubai* refers to the arrangement, or layout, of a piece of calligraphic work. When we look at a painting, we first judge its beauty from looking at it as a whole, and then we study the details. Similarly, when we hear music we appreciate the whole piece, rather than the individual parts.

Calligraphy is appreciated in exactly the same way, and its critics always comment on the whole work before studying its parts in detail.

Whether calligraphy is written in the formal, the official, or the seal script, its overall arrangement is fundamental. It would seem at first that there are no such rules in the cursive and running

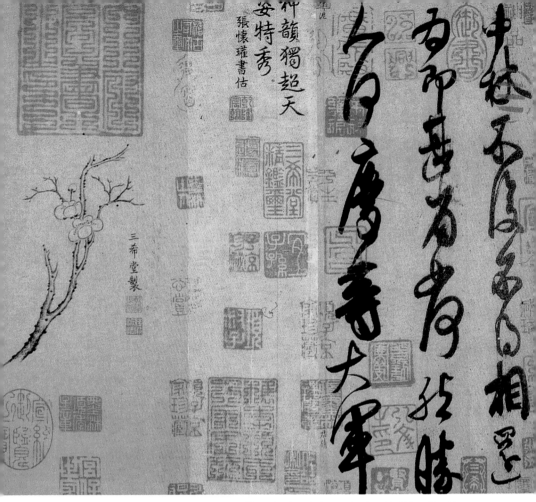

神韻獨超天

安特秀

張懷瓘書估

三希堂製

Part of the *Copybook on Mid-Autumn Festival*, written in the running hand by Wang Xianzhi of the Jin Dynasty.

hands, but this is not so. In the wild cursive hand in particular, the calligrapher aims to write with dynamism and grace, and pays great attention to the overall organization of the characters. Although a calligrapher may change their approach according to the situation, they still stick closely to the rules.

A good calligrapher is said to be like a control system engineer. Just as an engineer uses his knowledge of mathematics to draw up a plan for a complicated project, a "calligraphic engineer" uses data based on strokes, characters and lines to complete his calligraphic plan.

The most important part of a calligraphic work's composition is the liaison between the characters and lines, to create rhythm in changes and dynamics in stillness. This liaison can be achieved in three ways:

Linkage

The characters in each line should match each other, and be linked to each other, in both shape and manner. Writing characters is said to be like entertaining guests; they should all be made to fit in, and nobody should be left out.

A good example of linkage in calligraphy is the *Mid-Autumn Festival*, written in the running hand by Wang Xianzhi (344–386), the son of the famous calligrapher Wang Xizhi. Although only twenty-two characters are visible, they clearly demonstrate coherence, because each character or stroke is connected in a "one-way stroke of writing." This scroll was collected by the Ming Emperor Qianlong (1735–96) and was displayed in his Sanxi studio.

The beauty of true and false

In calligraphic works, the strokes are seen to be "real" or "true," and the spaces between characters and lines "empty" or "false." This can be likened to traditional opera, in which the vocal part is true, while the independent instrumental music is empty, and the two come together to create atmosphere. In Western music, it is said that the fading of the music represents a transition from true to false, with the two aspects playing complimentary roles. This was described in a classical poem: "here quietness seems to be noise."

The coexistence of true and false also plays a role in Chinese horticulture, with buildings and bridges representing a true scene, and the surrounding landscape in the background representing a false scene. An example of this is the Summer Palace on the outskirts of Beijing, where the true man-made Longevity Hill and its pavilions, halls and courtyards co-exist with the false vast surface of the Kunming Lake and its surrounding hills.

In calligraphy, true and false are shown when the dots and strokes are placed on the paper. Unlike in other arts such as painting, calligraphers have time to think about their work and to revise it repeatedly. However, it is said that a good calligraphic work cannot be created without a strict and proficient mind and hand.

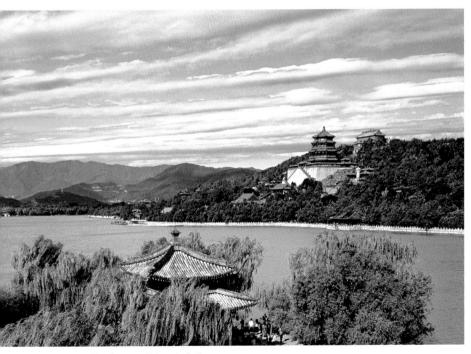

The Summer Palace in Beijing.

Good proportion

Proportion is another way in which changes are made, or strictness is adhered to. The seal, official and formal scripts follow the rule that all characters are placed on the central axis of a line, like beads along a hidden piece of string. However, the cursive and running scripts do not follow this rule. Most of their characters are not written along a central axis, and some are far away from it, forming angles of different degrees, and appearing crooked and disproportionate. In Du Fu's *Poem to He Lanxian*, written in the cursive hand by Huang Tinjian (1045–1105) of the Song Dynasty, all the characters were written freely.

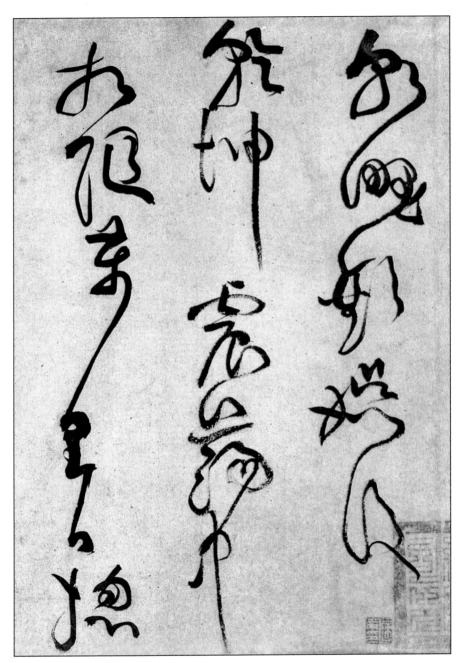

Part of *Du Fu's Poem to He Lanxian*, written in the cursive hand by Huang Tingjian of the Song Dynasty.

Creativity of Calligraphy

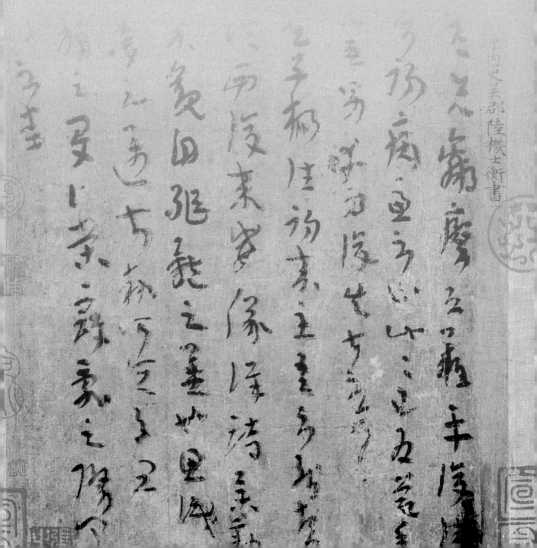

Diligent Practice

As the standards for assessing calligraphic works are so strict, it is easy to learn calligraphy but difficult to master the art. Calligraphers are always trying to improve their skills.

Beginners start by copying models of calligraphy, which can be found in bookstores. This first step takes several months and, after learning to copy several different styles, it should be possible to write characters freely and to start to establish an individual style.

As well as studying carved inscriptions and visiting calligraphy exhibitions, calligraphers can improve their artistic knowledge and creativity by learning about other fields. Ancient calligraphers advised artists to visit mountains and rivers, to observe natural scenery, and to increase their social knowledge in order to gain more appreciation of the world around them. A calligraphic critic once said that the characters reflect the calligrapher's mentality, and that works created by the more noble calligraphers are the most appreciated. Through this he implied that an artist's strong morality is essential for a credible calligraphic work.

Sun Guoting (646–691), a theorist of calligraphy from the Tang Dynasty,

Image of Yue Fei.

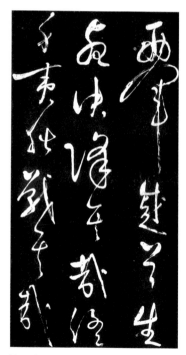

Part of the *Prayer for the Dead on an Ancient Battlefield*, said to have been written by Yue Fei.

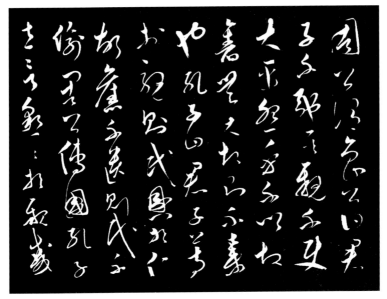

Part of *Mottoes by Xie Changyuan, Volume of Poetry,* written by Wen Tianxiang of the Song Dynasty.

Wen Tianxiang (1236–1283), a minister of the Song Dynasty, was also a man of letters and a renowned calligrapher.

believed that acquiring calligraphic skills would help the artist to mature and develop good character.

Two examples of how calligraphy has been seen to reflect the artist's integrity—one in a positive way and one in a negative way—are described below.

Yue Fei (1103–1142), a famous general during the Song Dynasty, was executed for treason. His calligraphic work *Prayer for the Dead on an Ancient Battlefield* was said to reflect his strong sentiments and heroism, but it was later discovered that the work was not created by him. It seems that his name was put to that piece of calligraphy in order to make people admire him.

Zhang Ruitu (1570–1641), an adopted son of the eunuch Wei Zhongxian and a royal councilor, created dramatic and energetic calligraphy in the cursive script. However he was despised by the people, which overshadowed his artistic accomplishments, and his work was ignored by critics.

Calligraphy enthusiasts find it difficult to separate calligraphic works from their views on the artist's character, so works created by those seen to have bad character are not well-liked.

Something which is said to make calligraphy attractive is its dynamics. The dynamics of a work make the enthusiast feel "closer" to the artist, even if they lived 1,000 years before, or live 1,000 miles away.

Thoughtful, experienced and imaginative experts on calligraphy can usually make more than one interpretation of a work. They draw on their aesthetic and cultural knowledge, and their life experiences, to explore its meaning and value, and to try to ascertain

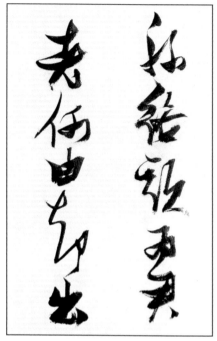

Part of *Trip to Congma by Prince Deng*, written in the running hand by Zhang Ruidu of the Ming Dynasty.

the artist's thoughts, feelings and principles. The calligrapher cannot easily explain these things, so it is up to the appreciator to find something valuable in a work, even those considered to be distasteful or superficial. This brings new meaning to a work, which is beneficial to the creation and development of calligraphy.

Conveying the Emotion of the Calligrapher

Calligraphers express their own personality, knowledge and sentiments through their work, and project their personalities into the characters they write.

One aim of the arts is to arouse "consciousness of life," and calligraphy achieves this through drawing parallels between its rhythm, and the rhythm of human emotion. Calligraphy enthusiasts believe that only music can arouse consciousness in the same way.

Chinese calligraphy is said to be "silent music," which reflects the secrets of the heart. People have different personalities and are influenced by the historical period in which they lived. They learn calligraphy from different teachers, and have different educations—thus, they write in different styles which express their individuality. This can explain why calligraphy has changed so much during the course of its development.

The passion that calligraphers put into their strokes is said to come from three sources: their character, knowledge and sentiments. Here we will introduce one of these sources—character.

Calligraphic works fall into two kinds: rigid and flexible. They are easy for the enthusiast to identify, critics often discuss them, and they are thought to reflect the calligrapher's personality.

Rigid calligraphic works are vigorous, bold and dramatic. Critics say that they are as tenacious as a dragon or tiger, as quick as a horse, as tight as a sword, as steep as a cliff, or as powerful as a giant crushing his opponent with his fist.

Flexible calligraphic works are delicate, elegant, warm and graceful. Critics compare them to beautiful women, dancers, gentle spring breezes, and plants.

The style of a calligraphic script can be either bold or soft, as illustrated by the official and formal scripts. Given below are two examples copied from stone inscriptions in the official script.

The *Tablet to Zhang Qian*, carved in 186 AD during the Eastern Han Dynasty, contains 672 characters, and is powerful and vigorous. The calligrapher deliberately made the strokes look grand, extending each character outward in order to make them

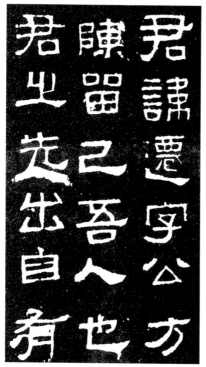

Part of the inscription on the *Tablet to Zhang Qian* in the official script, from the Eastern Han Dynasty.

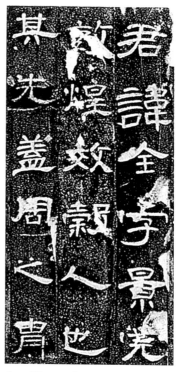

Part of *Tablet to Cao Quan* in official script from the Eastern Han Dynasty.

look larger. The uneven strokes, thick right-falling strokes, and horizontal strokes with an upward end demonstrate a brave and unrestrained style of writing, which can be interpreted as solemn but solid, and thoughtful but proud. The calligrapher's name is not on the work, but he could be seen as a confident, straightforward person. Today this work is kept in a temple in Tai'an, in the Shandong Province.

The *Tablet to Cao Quan*, a 900-character work carved a year earlier than *Tablet to Zhang Qian*, is graceful and smooth. Experts would liken it to a spring breeze, and the calligrapher might be seen as a refined and accomplished scholar. This tablet is preserved today in the Forest of Steles in Xi'an.

Part of *Chive Flowers* written in the running hand by Yang Ningshi of the Five Dynasties.

晝寢乍興輙飢正甚忽蒙
間翰猥賜鹽豉當一葉和
秋之初乃韭花逞味之始肷
其肥羜實謂珍羞充腹
之餘銘肌載切謹修狀陳

The two examples presented below, provide a further illustration of the relationship between personality and writing style.

The case of Yang Ningshi (873–954), of the Five Dynasties (907–960), provides a further illustration of the relationship between personality and calligraphy. He was a highly-ranked official and the son of the grand councilor. However, because he lived in troubled times, Yang pretended to be foolish and ignorant, neglecting his official duties and spent his time visiting scenic spots. This enabled him to retain his integrity as a Confucian scholar, and to avoid becoming embroiled in the political intrigues of the period. This is reflected in his calligraphy, which

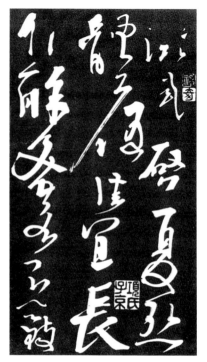

Part of *Summer Heat*, written in the running hand by Yang Ningshi of the Five Dynasties.

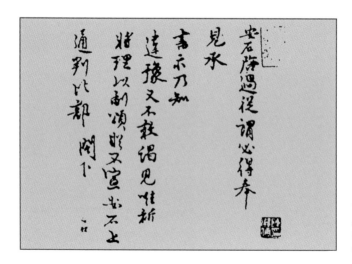

The *Copybook of Association*, written in the running hand by Wang Anshi of the Song Dynasty.

looks innocent, unrestrained and wild. Readers of his *Chive Flowers*, composed as a thank you letter on receipt of some delicious chives, admired this style for being natural and free-spirited. However the style of another of his books, *Summer Heat*, written in the running hand, looks rushed and disorderly, suggesting that he was also forgetful and rebellious.

Wang Anshi (1021–1086), a politician, writer and philosopher of the Song Dynasty, had great ambition when he was young. He suggested that political thinking should be non-conformist, and after accepting the post of grand councillor he passed several new laws. His poems expressed his controversial political and social views, and the unrestrained characters in his work reflect his intelligence and honesty, as well as showing him to be opinionated and temperamental.

Expressing the Talent of the Calligrapher

In addition to expressing the personality of the calligrapher, their work also expresses talent and creativity. This helps to promote the work; if it is unique and attractive people will like it, and it will remain sought after. This motivates the calligrapher to strive for perfection.

A letter written by Lu Ji (261–263), a calligrapher from the Jin Dynasty, is the earliest piece of handwriting on paper by a famous calligrapher that survives today. Now preserved in the Palace Museum in Beijing, it is viewed as a model of its genre. The letter, consisting of eight-four characters and nine lines, talks about the lives of the writer's relatives and friends during a civil war. It was created with a worn-out brush, and the characters are similar to both the Zhang cursive (memorial) script and the Jin cursive script. Lu Ji was born into an aristocratic family, and had a good reputation as an essay-writer, but he fell victim to political intrigue, and died at the age of forty-two.

Wu Zetian (624–705), the only empress in Chinese History, was also a calligrapher, and copied the works of Wang Xizhi and Wanat Xianzhi of the Jin Dynasty. Her *Tablet to Prince Shengxian*, written in the running script, shows full, bold dots and strokes. She was an extravagant empress who encountered significant opposition and, during her reign, dominated and re-named the Tang Dynasty. Nevertheless, she is greatly admired as a calligrapher, being held second only to the famous calligrapher Madam Wei, or Wei Shuo (272–349), a teacher of the young Wang Xizhi.

A skilled calligrapher understands how important it is to master the techniques of the art, and strives to make a work

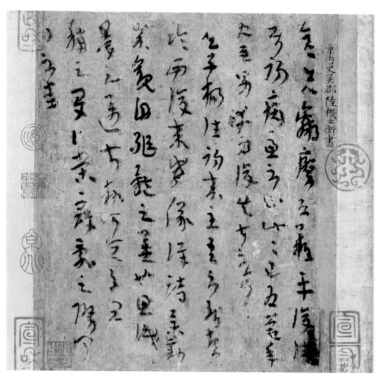

Part of the *Recovery Copybook*, written by Lu Ji of the Jin Dynasty.

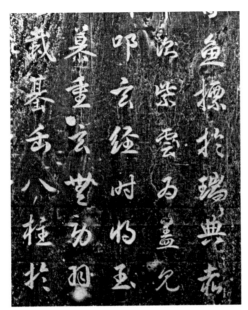

Part of the *Tablet to Prince Shengxian*, written in the running hand by Wu Zetian of the Tang Dynasty.

look beautiful. These skills are gained by constant observation and practice, which can sometimes happen consciously, and sometimes unconsciously, developing gradually over time. There are some interesting stories about how the skills of famous calligraphers were reflected in their work.

Li Yang Bing, a great calligrapher of the Tang Dynasty, brought character to his work by observing nature. He said he became familiar with round, square, flowing and standing forms from the Earth, mountains and rivers; horizontal and vertical movements from the sun, moon and stars; growth and spreading from clouds, sunrise, sunset and plants; and the actions of bending, spreading and flying from insects, fish, birds and animals. His *Record of Three Tombs* written in the seal script, is said to be one of the calligraphic wonders of the Tang Dynasty, famed for its graceful, even and delicate strokes.

The brush movements used by Lei Jianfu, a governor of Sichuan in the tenth century, were inspired by the sound of flowing water. He felt that his running hand was not as natural as that of his predecessors, and one day, when he heard the noise of surging river water, he put a piece of paper on his table and tried to convey the rhythm and movement of the current through characters. This greatly improved his calligraphic technique.

Zhu Changwen of the Song Dynasty described the works of Yan Zhenqing of the Tang Dynasty, as follows:

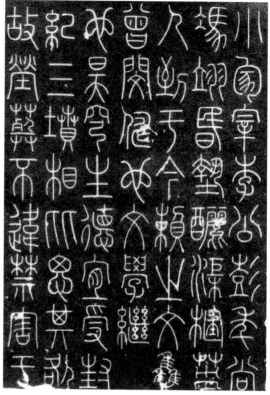

Part of the *Record of Three Tombs*, written in the seal script by Li Yang Bing of the Tang Dynasty.

"The dot is like a dropping rock, the horizontal stroke like a shred of summer cloud, the hook like a bent golden ornament and the backwards hook like a crossbow ready to shoot." Calligraphers experience these things in nature and in their own lives, and then try to incorporate them into their work. There is no need to draw a real rock, cloud, piece of metal or bow, but the characters should represent their shapes and movements. Yan Zhenqing was very talented and creative in this respect, and had the courage and skills to apply it in his work.

Emotion, Wine and Running Style

Humans experience all kinds of emotions, such as happiness, hatred, grief, desire, love, and fear. All of these can affect the calligrapher's style.

Emotion falls into two categories: positive and negative. The *Copybook of Narration of Myself*, by Huai Su (737–799), a master of the cursive script, shows how calligraphy might be written when the artist is feeling positive. Huai Su was a monk who lived during the Tang Dynasty, but he was a heavy drinker, and did not conform to monastic rules. His copybook has 126 lines, and in it he provides an account of his life as well as demonstrating his accomplished technique. Huai quotes verses and sentences from well-known poets, and his freedom and contentment are illustrated in his romantic and free strokes. Like a symphony, the characters are full of life and rhythm.

Lu You (1125–1210), a Song Dynasty poet, wrote 9,300 poems. One of them, *Cursive Calligraphy*, tells of his experience of creating a calligraphic work when he was depressed. Eager to

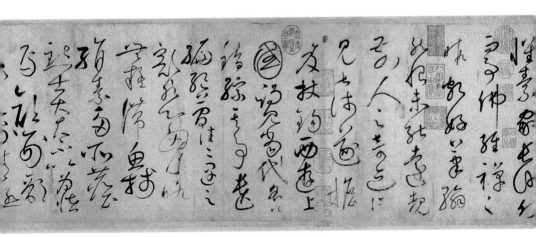

The *Copybook of Narration of Myself* in the wild cursive hand by Huai Su of the Tang Dynasty.

do something for his country, he had encouraged people to resist foreign invaders, and when he was young he had fought on the warfront several times. At the age of fifty-seven, he returned to his hometown disillusioned with politics.

All my money has gone on three thousand gallons of wine
Yet I cannot overcome my infinite sadness
As I drink today my eyes flash fire
I seize my brush and look round, the whole world shrinks
And in a flash, unwitting, I start to write.
A storm rages in my breast, heaven lends me strength
As when dragons war in the waste, murky, reeking of blood
Or demons topple down crags and the moon turns dark.
At this moment, all sadness is driven from my heart
I pound the couch with a cry, and my cap falls off.
The fine paper of Suzhou and Chengdu will not serve
Instead I write on the thirty-foot wall of my room.

Sadly, his own calligraphic interpretation of this poem has been lost.

The two calligraphers mentioned above created dramatic works in the cursive or wild cursive script when they were under the influence of alcohol. As drinking lowers inhibitions, a drunken calligrapher ignores customs and rules, and creates a work with greater freedom of expression.

We will now look at the features of the cursive script. Unlike other scripts, the strokes in the cursive script are always linked together, and some are written with a semi-dry brush. Sometimes the characters are slanted, depending on the calligrapher's individual style. The space between the lines is sometimes narrow and sometimes wide. These irregular rules are said to reflect the calligrapher's feelings of unease.

The cursive script (especially the wild cursive script), is the most flexible style of calligraphy. This is similar to painting.

Like many calligraphic scripts, figure painting is much more restricted, whereas landscape painting, like the cursive script, allows more scope for the painter to be creative. In the cursive script the characters still have to be differentiated, but rules don't have to be followed so strictly, and the structure of the dots and strokes can be changed. The benefit of this is that the calligrapher is free to express his feelings, and to show off his technique.

It is important to stress, though, that the calligrapher's emotions cannot be expressed directly through the characters themselves. They are simply involved in the creation of the work, influencing how the brush is moved. Calligraphers do not intend to express their specific feelings in their work; only rhythms, shapes and changes are displayed in the structure of the characters. But this is enough for the calligrapher, as they feel that their work expresses their soul in a way that spoken language cannot.

Calligraphy and Chinese Culture

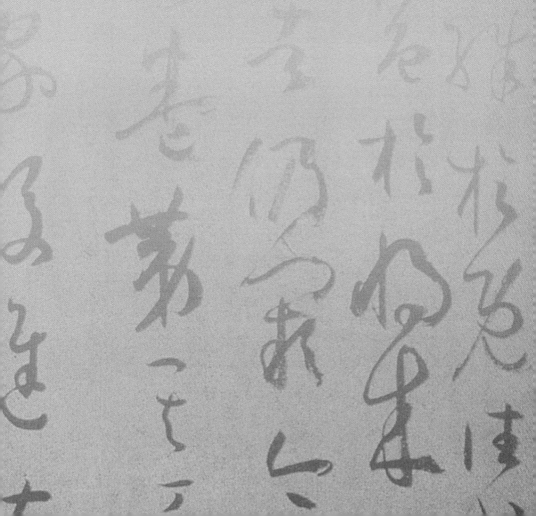

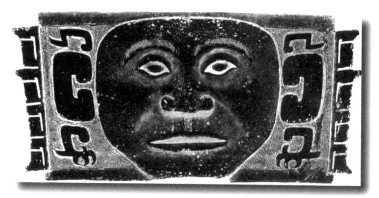

Human mask design on a bronze three-legged tripod dating from the Shang Dynasty.

The previous chapters have discussed the major functions and features of Chinese calligraphy, and the evolution of its different scripts. We will now turn to the relationship between calligraphy and traditional Chinese culture.

The history of Chinese calligraphy goes back several thousand years, and clearly reflects the cultural spirit of the Chinese people. Since the pre-Qin period, classical philosophical thinking has had a strong influence on Chinese culture. Confucian and Taoist thought in particular have played an important role in the development of calligraphy.

Confucius (551–479 BC), was the founder of the Confucian school which was predominant in China for more than 2,000 years, and dominated social and cultural trends in ancient China. The Confucian school promoted an idealized outlook

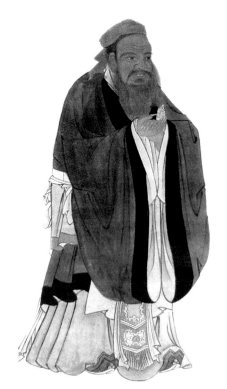

Image of Confucius.

on life, advocating progress, optimism, kindness, loyalty and forgiveness. In the field of art, it emphasized natural beauty and kindness, in the belief that art could shape a person's character, and creativity and spirituality, thus promoting a peaceful society.

The founder of Taoism, Lao Zi, lived in the same period as Confucius. The essence of Taoist thought was that behavior should obey natural laws, and that life should be approached with retreat and passivity. In art, Taoism emphasized the ideal of going back to nature and looking for natural qualities in human beings. Taoism promoted romanticism in art, and Taoists believed real beauty to be natural and spiritual, and not related to material benefits and needs. Taosim had a major influence on aesthetics in later generations.

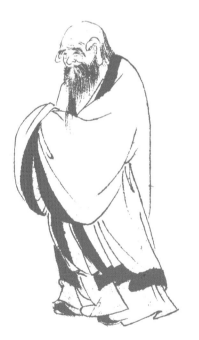

Image of Lao Zi.

The shared aesthetic values of these two schools are displayed in calligraphy in three ways: simplicity, charm, and neutralization.

The beauty of simplicity

Confucianism and Taoism shared the belief that all things in the world are made of the simplest materials and act according to the most fundamental laws.

The Book of Changes, a Confucian classic, says that the universe has two kinds of *qi* or energy: yin and yang. They are both contradictory and unified, and together can produce everything in the world. Simplicity allows people to understand the world, and makes all things rational.

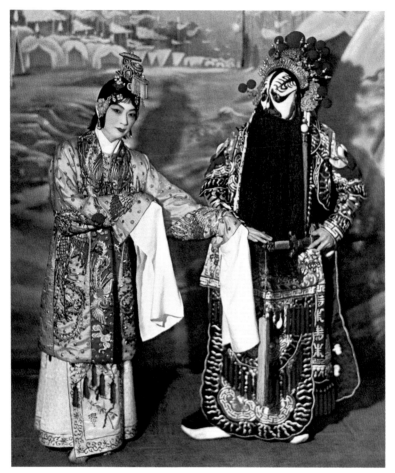

A scene from the Peking Opera *Xiang Yu the Conqueror Bids Farewell to His Favorite Concubine*.

The Book of Rights, another Confucian classic, says that the most popular music is plain and that the greatest rite is simple. These ideas are important in Chinese aesthetics and education.

Laozi, a classic of Taoism, states that there is a unified power which splits into two opposite parts. A third matter is then produced, which in turn produces myriad matters. This book also says that the strongest voice is mute, and that the most vivid image is plain.

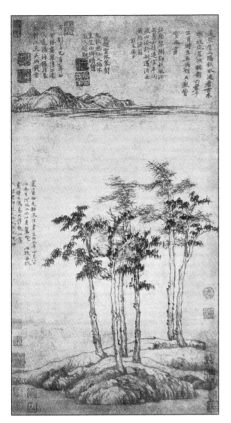

Picture of Six Gentlemen by Ni Zan of the Yuan Dynasty.

The idea that "simplicity is beauty" is reflected in the various kinds of Chinese art.

Traditional Chinese Opera has a simple technique of expression. The stage has no scenery, and few props, except for a desk and a chair. There are no doors for the actors to walk through, and no carriages in which they could sit. A long journey is represented in three or four steps, and a large army is portrayed by six or seven people. Actions such as rowing a boat, sitting in a sedan chair or shooting a wild goose are all conveyed through movement, so the audience have to imagine them.

An important principle in Chinese painting is to display the world in simple lines and colours. In freehand brush work in particular, the painter aims just to hint at the things in his mind, rather than creating sophisticated images. What he wants to convey is his imagination, creativity, and feelings, rather than careful observation and mimicry. Expressing things in a vague way is normally felt to have a greater effect.

Ni Zan (1301–1374) of the Yan Dynasty (1206–1368) was a great promoter of the simple painting style. His landscape paintings consist of very little brush work and very few figures. His paintings are simple but elegant and attractive, and had a great influence on later generations.

The beauty of conciseness

Chinese poems are famous for their conciseness. Like the montage technique used in film making, the lines in this poem link separate pictures together to achieve effect:

The marble steps with dew turn cold,
Silk socks are wet when night grows old.
She comes in, lowers the crystal screen,
Still gazing at the moon serene.

The poem above, *Waiting in Vain on Marble Steps* by Li Bai, a famous poet from the Tang Dynasty, describes in 20 characters a palace lady's sleepless night. The poem is poignant and moving:

Homeward I cast my eyes; long, long the road appears;
My old arms tremble and my sleeves are wet with tears.
Meeting you on a horse, I have no means to write.
What can I ask you but to tell them I'm all right?

This simple four-line poem, *On Meeting a Messenger Going to the Capital*, is written by Chen Shen (c.715–770), another leading Tang poet, and tells of his experience when he was stationed at a remote garrison outpost, and was missing his hometown.

Calligraphy is the simplest artistic endeavor, being composed of just dots and strokes. The variation and distribution of the lines is a simple but symbolic means of expression.

Ancient critics of calligraphy praised the ability of the strokes to express beauty in a simple and concise way. Zhong You (151–230) of the late Eastern Han Dynasty stated that "Handwriting is a dividing line composed of dots and strokes, but the beauty expressed by the handwriting is produced by people, and is an outer expression of the aesthetics and ideals of those people."

In his article *On Language*, Zhang Huaiguan, a scholar of the Tang Dynasty, wrote that "To express an idea in written language several characters or sentences are required. However

in calligraphy one character can express the whole soul of the calligrapher. This is the essence of simplicity."

The simplicity and conciseness of calligraphy are held to be its most endearing characteristics. All that is needed for its creation is paper, a brush, an ink stick and an ink stone. The calligrapher already has the characters to hand, through using them in their everyday life.

Yet although calligraphy is simple, it is difficult to master. Creating a whole work composed of lines and individual characters can be likened to an acrobat keeping his balance during a performance.

The beauty of rhythm and vigor

The Book of Changes says "Essence and breath form things." *Zhuangzi*, another famous Taoist book, says, "Human life is due to the collecting of the breath. When that is collected, there is life; when it is dispersed, there is death."

Ancient works on calligraphy state that momentum (energy)— meaning quality, character and vitality—is one of the basic elements of beauty in calligraphic work. In *Momentum*, Cai Yong of the Eastern Han Dynasty, the earliest calligraphy critic, says "yin and yang qi bring people to life."

Rhythm is different from momentum or energy, usually describing a pleasing sound. In the case of handwriting, it refers to the dots and strokes forming a dramatic, rhythmic calligraphic work.

Calligraphy is said to be the coming together of the rhythm and momentum of handwriting. Momentum is said to reflect the visible structure of the characters, which change frequently and demonstrate the calligrapher's skills, while rhythm reflects style, and conveys the calligrapher's emotions and imagination. As Sun Guoting says in his *Copybook of Calligraphy*, "Great changes take place at the tip of the writing brush," and "rhythm is reflected on

應不可雜　若兄佳成
都況克世君於期情
弟孫乃蔡羸垂仍摧
勿煞哀子春弟之二用
又一家得至

the paper." Rhythm and momentum are said to co-exist, like two sides of the same coin.

Liu Xizai (1813–1881), a literature and art critic from the Qing Dynasty, praised the beauty created by rhythm and momentum in calligraphy. In his *General Introduction to Calligraphy*, he says, "Rhythm means expression of emotions and feelings, and momentum means quality and style. Without rhythm and momentum it is not calligraphy." He also talked about the relationship between calligraphy and personal accomplishment. He said that rhythm and momentum have to express the calligrapher's mind; otherwise the work is not original. He emphasized that handwriting should be natural and should reflect the calligrapher himself, and that this is the only way to create a work with rhythm and energy.

The beauty of neutralization

Neutralization is a Confucian theory and was also seen as a moral standard. According to *The Book of Rites*, a classical work of Confucianism, neutralization can make everything in the world grow. Taoism says that harmony has priority over everything, and that people should act in accordance with nature.

With regard to literary and artistic creation, neutralization means a controlled expression of emotion, and a harmonious reflection of the relationship between the artist's feelings and the objects in his surrounding environment—a balanced integration of subject and object.

Sun Guoting was the first to include neutralization as one of the guiding principles of calligraphy. He believed that neutralization involved the coordination of the various organic elements of calligraphy, and that harmony in calligraphy was achieved by reflecting material things, while at the same time expressing the

Part of the *Copybook of Calligraphy*, written in the cursive script by Sun Guoting of the Tang Dynasty.

calligrapher's emotions. He said that calligraphy is a natural exposure of a person's emotion, but that this exposure should be controlled, in order to bring together both nature and personality.

Later, calligraphers interpreted neutralization in different ways. They said that calligraphers naturally demonstrate their emotions through their unrestrained handwriting but, if they can control this, the work has neutralization, making it more sophisticated.

The work of Wang Duo (1592–1652) of the late Ming and early Qing Dynasties is a good example of this. His cursive-script handwriting was pioneering, and his characters are said to have been like acrobatic movements in the air, but were still controlled.

The characters in the *Vertical Scroll of a Poem* by Gao Shi, for example, are vigorous but "flying," reaching the highest level of neutralization.

Yang Weizhen (1296–1370) of the Yuan Dynasty did not conform to the gentle style of Zhao Mengfu (1254–1322), which was long-established and dominant at the time. He created the unique "Tieya style," named after himself (Tieya was his

Part of *the Vertical Scroll of a Poem by Gao Shi*, written in the cursive script by Wang Duo of the late Ming and early Qing dynasties.

Part of *On Donations to Zhenjing Nunnery*, written in the running script by Yang Weizhen of the Yuan Dynasty.

Eight Eccentrics of Yangzhou
General term for a group of reformed painters famous in the painting circles of Yangzhou, Jiangsu Province, during the mid-Qing Dynasty (also known as "Yangzhou School"). Generally, the "Eight Eccentrics" refer to Wang Shishen, Zheng Xie, Gao Xiang, Jin Nong, Li Shan, Huang Shen, Li Fangying and Luo Pin. However there were in fact 16 or 17 painters associated with this school.
The Eight Eccentrics of Yangzhou detested the world and its ways, hated the dignitaries and understood the hardship of the people. They felt that the influence of thoughts, characters, knowledge and artistic talent upon the creation of painted works was very important, and their literary and calligraphic works were seen to be very cultured. They mainly used flowers as the subject of their paintings, and also drew hills, waters and characters.

variant name). In *On Donations to Zhenjing Nunnery*, which he wrote in the running script, some of the characters are big and some small; some are dry and some are wet; and some are in the regular script, some in the cursive script, and some in the classical style. The characters vary but are also integrated, providing a clear example of calligraphic neutralization.

Zheng Banqiao (or Zheng Xie, 1693–1765) of the mid-Qing Dynasty was one of the "Eight Eccentrics of Yangzhou," and was famous for his unique calligraphic style. He was once a county magistrate in the Shandong Province but, after a disagreement with his boss, went back to his hometown and made a living out of selling his paintings and calligraphic works. He would use several different scripts in one work, so any one page from his running-script copybook could include characters from the official,

Page from a running-script booklet written by Zheng Banqiao of the Qing Dynasty.

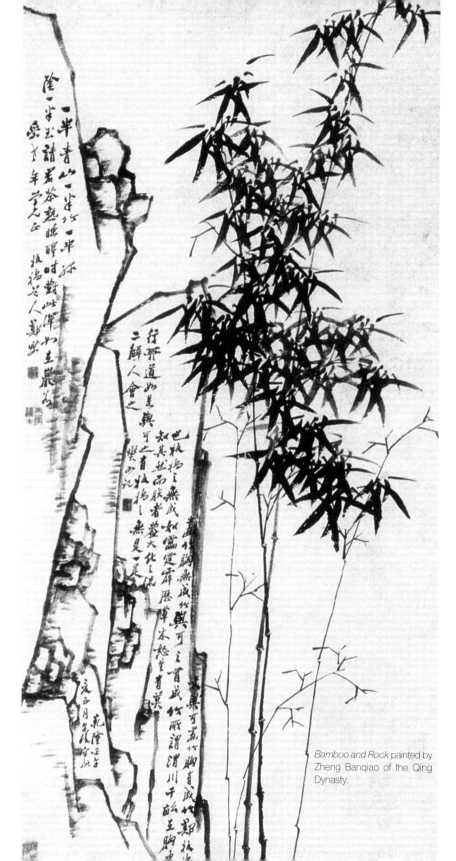

Bamboo and Rock painted by Zheng Banqiao of the Qing Dynasty.

cursive and running scripts. Some of his work echoes the styles of Wang Xizhi and Wang Xianzhi, some are in the vigorous style of the Han steles, and some are in the free, wild cursive script. His handwriting shows great variation but it is harmonious rather than disordered. Zheng Banqiao enjoyed painting bamboo, rocks, and orchids. He is said to have painted orchids as though he was writing characters, and to have written characters as though he was painting orchids.

Calligraphy Masters

Father and Son: Leaders of the Time

In the previous chapters we have introduced the main functions of Chinese calligraphy and its characters. Now we will look at some key trends in the development of Chinese calligraphy in the Jin, Tang, Song and Qing Dynasties. These trends were led by the calligraphic masters of those periods.

In this chapter we will look at the influential father and son from the Jin Dynasty, Wang Xizhi (303–361) and Wang Xianzhi (344–386).

Xizhi was known as a wise man. Born into an aristocratic family, his grandfather, father and two brothers were senior officials of the imperial court. His family was also known for their calligraphy. Historical records show that out of almost one hundred famous calligraphers from the Jin Dynasty, twenty were from the Wang clan.

In his youth, Wang Xizhi was an official, who then gave up official life and became a recluse, devoting his life to calligraphy. It is said that he created nearly 1,000 calligraphic works, but none of the originals have survived, and all we can see today is a dozen or so copies. Most of

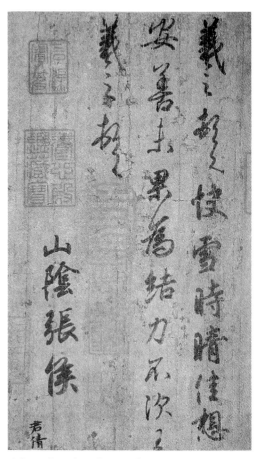

A Sunny Day after a Pleasant Snow, written in the running script by Wang Xizhi of the Jin Dynasty.

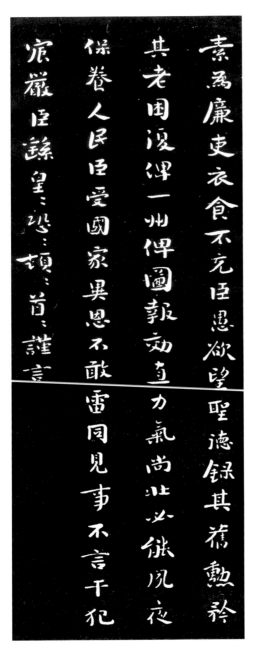

素為廉吏衣食不充臣愚欲望聖德錄其舊勳矜其老困復俾一州俾圖報効力氣尚此必微況夜保養人民臣受國家異恩不敢雷同見事不言干犯痕巖臣繇皇恐恐頓頓首謹言

Part of *Memorial on Jizhi*, written in the regular script by Zhong You of the Eastern Han Dynasty.

these are in the running and regular scripts, just one is in the cursive script.

Wang Xizhi first learnt calligraphy from his father, and then studied with the female calligrapher Madam Wei. In his middle age, he crossed the Yangtze River to visit the mountains in north China, where he met many famous calligraphers and examined many stele inscriptions. He also studied calligraphic theory and developed a new natural and free style, with cut-off but continuous strokes. For a time, his style was adopted by students of Yu Yi (305–545), another famous calligrapher of the time. Yu Yi was furious that his students were using such a controversial script, even though he praised the new style as "God's Hand."

Wang's new style was a landmark in the history of Chinese calligraphy, and was seen as a welcome departure from the old styles of Zhong You and Zhang Zhi of the Eastern Han Dynasty.

Xie An (320–385), a grand councilor of the Jin Dynasty,

was a good friend of Wang Xizhi, and attended the famous
gathering at the Orchid Pavilion mentioned earlier in this book.
Xie was skilled in the running hand and also learnt the cursive
script from Wang. By comparing his hand to that of the *Preface to
the Collection of Orchid Pavilion Poems*, we can see how fresh and
creative Wang Xizhi's new style was.

Wang Xianzhi was once an official of the imperial court, and
of a higher rank than his father. Like his father, he was known
as a man of integrity, and when Xie An asked him to write
an inscription for a new hall, he refused, because he thought
it had been built against the will of the people. He was not
happy serving the imperial court, and expressed this in his
calligraphic work *On
my Resignation from the
Position of Zhongling.*

Legend has it that
in his teens, Wang
Xianzhi told his
father that the Zhang
cursive script was
too restrictive, and
proposed a new style
which sat half way
between the cursive
and running scripts.
Later, Wang Xianzhi
developed the unique
running-cursive
script. His *Letter
About a Duck's Head
Pill* in the running
script contains fifteen
characters displayed

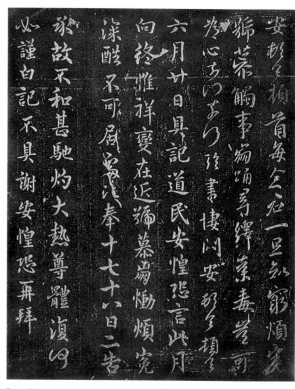

Part of two copybooks of the running script by Xie An of the Jin Dynasty.

The *Letter About a Duck's Head Pill*, written in the running script by Wang Xianzhi of the Jin Dynasty.

in two lines. All of the characters are natural, smooth, unrestrained and lyrical. In this respect, he surpassed his father.

According to Sun Guoting's *Copybook of Calligraphy*, Xie An once asked Wang Xianzhi how he saw his handwriting as different from his father's style, and he said that he felt his own was better. Xie An replied that the critics did not agree, but Wang insisted that the critics did not understand. But although Sun Guoting criticized Wang for his claim, the copybook shows that his handwriting was, arguably, more creative and skilled than that of his father.

In *The Meaning of Calligraphy*, Zhang Huaiguan of the Tang Dynasty claimed that Wang Xianzhi possessed exceptional talent, and developed a new style which was different from both the running and cursive scripts. This new, unrestrained style became very fashionable.

The Jin Dynasty (265–420) was racked with internal conflicts and foreign invasions, and many people abandoned politics for intellectual and philosophical pursuits. Scholars sought to explore life, and demanded liberation, in a revival of the "hundred schools of thought."

Following this trend, scholars sought to rid themselves of the constraints associated with the Confucian doctrine, and looked for ways to express emotions and feelings in a more adventurous way. Calligraphy, the most intense expression of creativity of the Jin Dynasty, achieved this through forming new patterns of dots and strokes. Calligraphers encouraged each other to modernize their handwriting techniques, taking calligraphic art to a new historical peak.

Hundred Schools of Thought
This refers to the social situation and general mood during the Warring-States period (475–221 BC) when academics disagreed with each other. Ideologists representing different social classes wrote books and pushed their ideas one after another, and recruited disciples. A diverse range of schools of thought subsequently appeared, including Confucianism, Taoism, Mohism, the School of Logicians, Legalism, and the Yin-Yang School, who debated with each other in terms of theory on the universe, theory of knowledge, the relationship between names and facts, social ethics, ritual laws and political views. The most influential schools among the "hundred schools" are Confucianism, Taoism, and Legalism. The "contention of a hundred schools of thought" not only greatly promoted the development of academia and culture at the time, but also set a good cultural foundation for that turbulent period.

Masters of the Tang Dynasty

During the Tang Dynasty, calligraphy developed and changed. This chapter introduces Zhu Suilang and Yang Zhenqing, the two leading calligraphers at the time. In the early years of the Tang Dynasty, there were four famous calligraphers (in order of age): Ouyang Xun (557–641), Yu Shinan (558–638), Chu Suiliang (596–658) and Xue Ji (649–713). The most accomplished of these was Chu Suiliang.

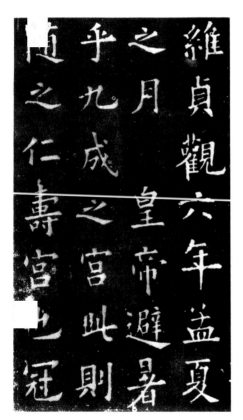

Part of *Jiucheng Palace* by Ouyang Xun of the Tang Dynasty.
Ouyang Xun (557–641) was one of the four famous calligraphers of the early Tang Dynasty. Chu Suiliang studied his style for several years.

Chu Suiliang was once a high-ranking official of the imperial court, and wrote the draft of the declaration made by Emperor Taizong when he abdicated in favour of his son. When the new emperor, Gaozong, married Wu Zetian, one of his father's lovers, Chu protested, and was exiled from the capital.

Chu studied the calligraphic styles of Ouyang Xun and Wang Xizhi, and the Han official script. He combined these together to create a new type of script, abandoning the "silkworm's head" and the "wild goose's tail." His calligraphic style underwent three major changes. *The Preface to the Three Collections of Buddhist Scriptures* is one of his masterpieces. Written in the running script, the characters are thin and smooth, but grand. It

became fashionable to copy his handwriting, and he was renowned as a calligraphic master of the Tang Dynasty.

Yan Zhenqing (708–784) was born into an aristocratic family. His grandfather and uncle were calligraphers, who brought him up to love the art. Yan passed the highest imperial examination and for a time became an official. His vigorous handwriting in the regular and running scripts was said to reflect his great integrity.

At first, Yan imitated Chu's style, and later Wang Xizhi's, but rather than just copying it he explored different techniques. This resulted in a dramatic and striking new style, which reflected the flourishing culture of the Tang Dynasty. His style was admired and followed by later generations.

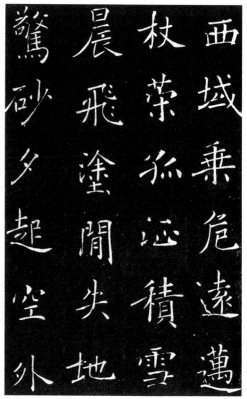

Part of the *Preface to the Three Collections of Buddhist Scriptures*, written in the regular script by Chu Suiliang of the Tang Dynasty.

Liu Gongquan (778–865) was born seventy years later than Yan, whose style he studied, but he was to become just as famous.

Liu Gongquan served for several emperors, who encouraged him in his calligraphy. Liu's characters are powerful but smooth, and the strokes extend outward. He is famous for his command of tension, and the cohesion of his ink.

Like Yan's style, Liu's calligraphy was copied widely by the people of later generations.

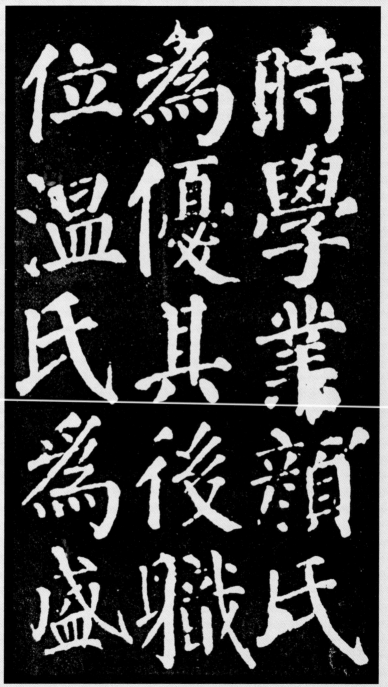

Part of the *Tablet to Yan Qinli*, written in the regular script by Yan Zhenqing of the Tang Dynasty.

Rigor was the most important characteristic of calligraphy in the Tang Dynasty. The Tang style is quite different from that of the Jin Dynasty, which is elegant, graceful and unrestrained in comparison to the Tang style's strict, neat nature. The Tang style was easy to learn, so from the Tang Dynasty onwards, many more people came to practice calligraphy.

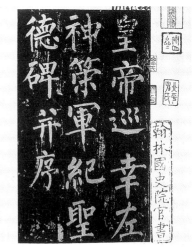

Part of the *Tablet to the Army of Inspired Strategy* by Liu Gongquan of the Tang Dynasty.

Three Masters Focusing on Temperament and Taste

We will now introduce three masters of calligraphy from the Song Dynasty: Su Shi, Huang Tingjian and Mi Fu. They were famous because they developed a style which focused on the expression of emotions and feelings.

Su Shi (1037–1101) was known both for his wisdom and his talent as a painter and a calligrapher. His bold poems constituted his own unique school and were greatly admired by both the people of his time, and those of later generations. He had a strong command of the running and regular scripts. His political life, however, was turbulent, and he was exiled from the capital several times. Once he was slandered and jailed for 130 days. He was saved by the empress and key ministers, but was then exiled to Huangzhou in South China.

In his third year in Huangzhou, he wrote a poem describing his unhappiness there, from which he copied his famous *Cold Food*

Observance. Containing 120 characters and twenty-four sentences, the changes in the strokes are said to express his depression in a profound artistic way.

At the beginning of the poem, the characters progress slowly, the space between them is even, and he uses bent strokes and lines to convey his troubled mind. The last vertical stroke of the second character on the second line looks like a sharp sword, which reflects strong emotion.

What we see below is part of this work. The last sentence says that he wants to go back to the capital city, but there are nine gates to pass through, and that he wants to go back to his hometown as the tombs of his relatives are far away. The characters are of different sizes, showing strong contrasts, demonstrating his unsettled mind and his feelings of resentment, confusion and pessimism. This is also conveyed in the shapes of the dots and strokes, their strength, speed,

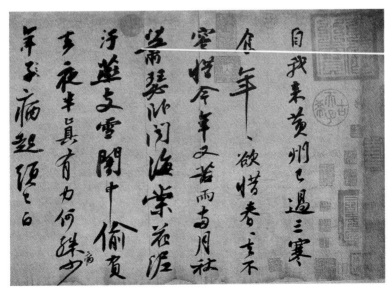

Part of the *Cold Food Observance*, written in the running script by Su Shi of the Song Dynasty.

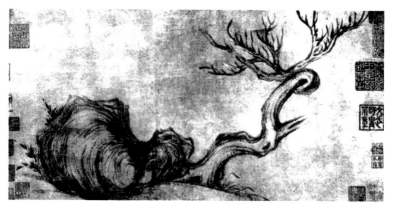

Picture of Withered Tree and Strange Rock by Su Shi of the Song Dynasty.

density, and looseness, and the ups and downs of their rhythm.

Su Shi left behind many poems and articles on calligraphy. One said "Innocence and romanticism are my teachers, with imagination and creation. I finish my calligraphic works, free from traditional rules. I write dots and strokes freely, without any restrictions." He once said that he enjoyed handwriting, and said that it was better for old people to write than to play chess. In a postscript that he wrote on one of his friend's calligraphic works, he said that "calligraphy was a game played with strokes." Su Shi also loved painting. His paintings do not depict concrete objects, but the water, rocks and hills in his mind, or the resentment in his heart.

Huang Tingjian (1045–1105) was a master of poetry and calligraphy. As an official he was controversial and was exiled several times from the capital to remote places. His calligraphic works show power and variation. The characters in his regular and running scripts extend outward, and his handwriting in the wild cursive script is more skilled than that of his teacher. His *Quotations from Wenyi* shows his straightforward and expressive nature.

Part of the *Copybook on Taking Honor Seats*, written in the wild cursive script by Huang Tingjian of the Song Dynasty.

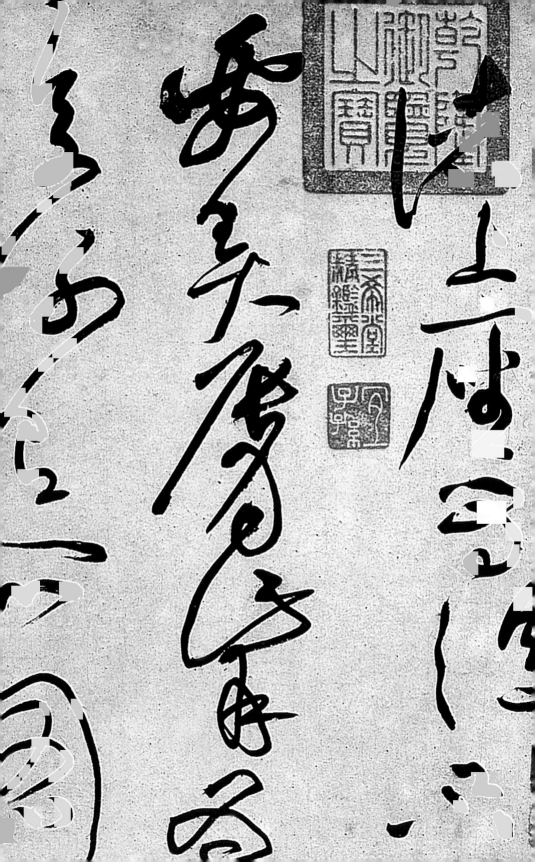

Huang Tingjian emphasized gracefulness in his calligraphy and, like Su Shi, compared it to a game.

Mi Fu (1031–1107) was also good at poetry and calligraphy. His brave, relentless nature is reflected in his light, unrestrained and natural running and cursive script handwriting, as demonstrated in his *Scroll of Tiaoxi Poems*, in the running hand. Like his calligraphic works, Mi Fu's writings on calligraphy also expressed his preference for graceful and romantic touches, and he assessed the work of his predecessors by those standards. He even criticized Yan Zhenqing, a famous calligrapher of the mid-Tang Dynasty whose work was said to represent a new chapter in the development of the art, for having too plain a style. Like Su Shi and Huang Tingjian, he believed that calligraphy was a game, so "it is unnecessary to consider the characters as beautiful or ugly. It is strong enough to be satisfied with your work. To write what you are thinking is a game of interest and spirit."

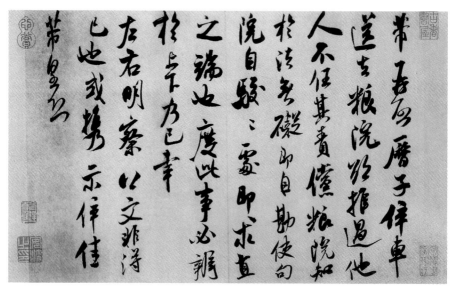

Part of the *Tiaoxi Poetry Anthology* in the running script by Mi Fu of the Song Dynasty.

These three calligraphic masters from the Song Dynasty were influenced by the prevailing cultural and aesthetic ideas of the time. The Song Dynasty inherited the rich culture of the Tang Dynasty. However, it was a period of economic prosperity but weak military defense, which resulted in a series of successful attacks by neighboring countries. Under these circumstances, the literati and scholars of the Song Dynasty were not as enterprising and aspirant as their counterparts in the prime of the Tang Dynasty. As they were unable to achieve the goal of building a prosperous nation according to Confucian ideals, poetry, calligraphy and other artistic activities became their way to vent their disappointment and to channel their creative energies. Unlike the energetic style of the Tang Dynasty, the poetry of the Song Dynasty was deeper and colder. Tang paintings depict landscapes, flowers and birds, with natural scenes in the background, but in Song paintings, natural scenes are the main focus.

For this reason, the people of the Song Dynasty liked running-script calligraphy. Sitting between the regular and cursive script, it was not as rigorous as the former, but it was easier to learn than the latter. The running script was easy to create with a brush, and this made it easy for the calligrapher to express peace of mind and an aspiration to be happy.

The sentiments of the Song calligraphers were similar to the gracefulness valued by the Jin calligraphers, but also different. Both emphasized the beauty of the image, but the Jin style depicted a peaceful and quiet tone, whereas Song style, devoid of constraints and pressures, was bolder and less restrained. The Song people are thought to have achieved the best expression and understanding of poetry and handwriting. Although the Song calligraphers were taught by those of the Jin Dynasty, they outdid them in technique and expression. This can be seen clearly if we compare the work of the Song calligraphers with that of the Jin calligraphers.

Modern Reforms

In the mid-nineteenth century, calligraphy underwent some major changes. In the early Qing Dynasty, two emperors encouraged the printing of copybooks in the regular but soft style of Zhao Mengfu of the Yuan Dynasty, and Dong Qichang (1555–1636) of the Ming Dynasty. This marked the beginning of a graceful but monotonous new style.

Ancient bronze and stone inscriptions were also rediscovered at that time, and writers and scholars working during Ming and Qing periods of literary inquisition, when extremely harsh penalties for writing words deemed offensive by the ruler were imposed, used the copying of ancient characters as a new way of expressing their emotions. The more they practiced, the more they came to realize the importance of the shapes and characters in artistic expression, and so imitations of these ancient styles became popular. This reform continued into the late nineteenth century.

Kang Youwei (1858–1927), a famous figure in modern Chinese history, recommended copying the style of the stone inscriptions from the Northern Wei Dynasty. He bought and studied many copybooks and stone inscription rubbings from that period and, in 1899, wrote a 60,000-word book in an attempt to modernize calligraphy. It was a success, although his attempt at political reform failed.

The tablet script that Kang recommended was the one used for inscriptions on tombstones during the Northern Wei Dynasty (fourth-sixth century AD), found in the Henan and Shadong provinces. It belongs to the regular script genre, and most of the inscriptions were written or carved by less-educated rural people, meaning that the patterns were unrefined and full of errors. Because of this, the script had been ignored by calligraphers for a long time, but Kang thought it showed strength and originality.

In the first chapter of this book, we saw how Kang wanted to change the style of calligraphy because he felt that, like politics, it needed reform. Inspired by his view, calligraphers dared to make suggestions to the higher authorities. Students of calligraphy studied and copied the Northern Wei Dynasty inscriptions, and the movement spread rapidly as people adopted that style.

At the same time, scholars became very interested in the seal script on bronze objects and tortoiseshells, the official script from ancient tablets, and the old-style characters on wooden strips, stones, tile-ends and silk fabrics, and used them as a basis for innovation. Kang himself combined the stone script with the Tang and Song styles of Ouyang Xun, Su Shi and Huang Tingjian, and developed his own Kang style, which had an intense and dynamic pattern.

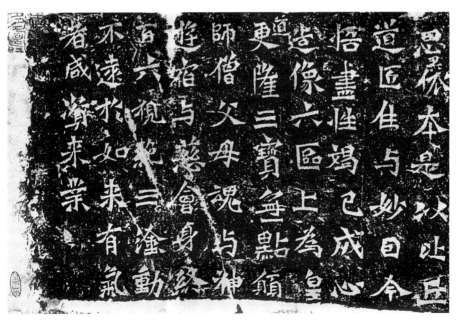

A rubbing copy of a tablet from the Northern Wei Dynasty.

雄奇倚泰岱
矢章上石渠

在崑仑只

康有为

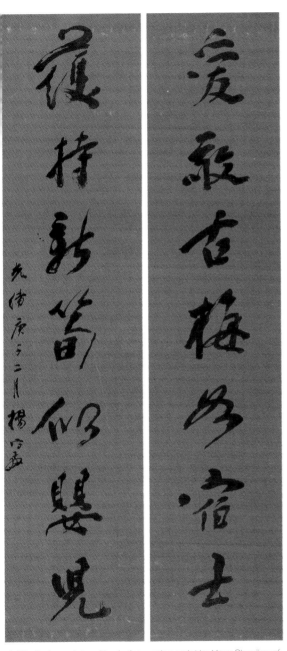

Antithetical couplets written in the running script by Yang Shoujing of the late Qing Dynasty.

Kang Youwei and other calligraphers of his time followed this reform.

The calligrapher Yang Shoujing (1839–1915) from the late Qing Dynasty, also a scholar of bronze and stone inscriptions, studied the rubbings of stone inscriptions in depth. He gave equal importance to copybooks and to rubbings in practicing calligraphy. He believed that it was detrimental to a calligrapher to pay attention only to one or the other, and he concluded that rubbings and copybooks should always be studied in tandem.

Among the modern calligraphers, Lu Weizhao (1988–1980), a professor at the Zhejiang Academy of Fine Art, was a leading poet, calligrapher and painter, and was also an expert in history, philosophy and music. He developed a new style of calligraphy which sat between the stamp and official scripts, in

Antithetical couplets written in the running script by Kang Youwei.

which he changed the nature of the characters, rebelling against the principle of even, balanced and symmetrical patterns. This script retained the features of the bronze and stone inscriptions, but added a running style, in which the left and right parts of a seal-script character are parted, one being longer and one being shorter. The space between the horizontal lines is narrow, while the space between the vertical lines is wide. This makes the whole work look quite different from those created in the ancient seal script.

The modern calligrapher Wu Shangjie created a work in the style of the *Cuanbaozi Tablet* from the Jin Dynasty, which is between the official and regular scripts. It does not display the gracefulness of the stone carving of the southern tablet, and it is as simple as work from 1,500 years ago. He added to it the features of the cursive script in order to create an aesthetic effect.

The changes in Chinese calligraphy over the four

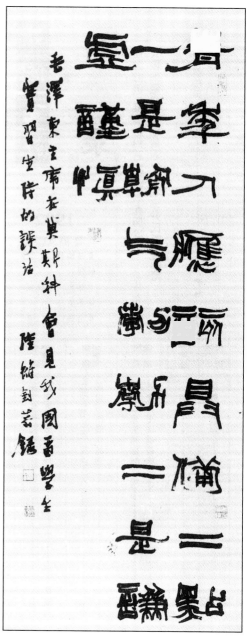

A pair of vertical couplets written in the seal script by Lu Weizhao.

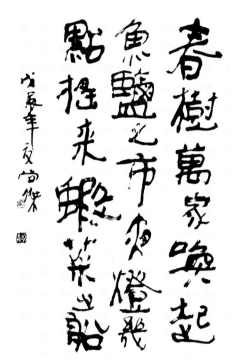

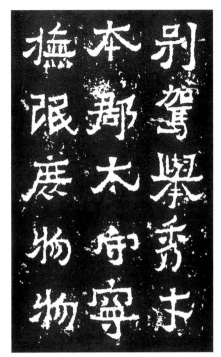

Antithetical couplets written in the tablet script by Wu Shangjie.

Part of the *Cuanbaozi Tablet* from the Jin Dynasty.

dynasties described in this chapter show the evolutionary track of its development. The calligraphic style of the Jin Dynasty, which placed importance on gracefulness, was reversed by the strong moral standards of the Tang Dynasty. In turn the style of the Song Dynasty reversed that of the Tang Dynasty, but instead of simply going back to the style of the Jin Dynasty, it absorbed the essence of both.

Renaissance of Calligraphy

The Splendor of Calligraphy Today

In the half-century following the fall of the Qing Dynasty in 1911, twenty years of conflict took place, followed by Japanese invasion. In February 1998, an exhibition of works by famous calligraphers from that troubled period was held at the National Art Museum in Beijing by the China Federation of Literary and Art Circles and the Chinese Calligrapher's Association. The exhibition offered the opportunity to view original works by some hundred famous calligraphers. Some of them were thinkers or politicians, and some were scholars or artists, including Kang Youwei, Liang Qichao, Sun Yat-sen, Mao Zedong, Zhou Enlai, Guo Moruo and Wu Changshuo. Created in many of the different script styles, these works demonstrated a range of unique techniques and personalities. Some of the calligraphers had their own techniques, while others combined their individual style with those of others.

The north gate of the Palace Museum, Beijing.
The calligraphy on the horizontal plaque was written by Guo Moruo (1892–1978).

Since the founding of New China in 1949, and particularly in the decades since economic reform, Chinese calligraphy has entered a period of development that has seldom been seen before. The national economy has grown steadily, and living standards have improved greatly. Calligraphy and painting have become part of the culture of the Chinese people, breaking the older tradition in which it was only practiced by literary writers. Calligraphy is now taught in schools, colleges and universities, and courses are also available for retired people. A range of books, newspapers and magazines specialize in calligraphy, and TV stations show lectures on it. The Chinese Calligraphers' Association, established in 1981, has branches in all provinces, autonomous regions and municipalities, and it regularly sponsors exhibitions, domestic and international conferences, and other activities.

An 85-year-old man taking a calligraphy test. Xuzhou, Jiansu, October 2003.

Remarkable progress has been also been achieved in the field of calligraphic theory. Many relics connected with the art have been discovered, such as inscriptions on tortoiseshells, bamboo strips, and silk fabrics. Many reference books and teaching materials have been published, and researchers in calligraphy have been informed by a variety of other fields and arts, such as science, philosophy, psychology, music, dance and poetry. The Chinese

are proud that calligraphy is now enjoying the most successful period in its history.

Chinese Calligraphy Spreads Worldwide

In the second or third century, Chinese calligraphy was introduced to the Korean peninsula, and flourished during the seventh century. During that time, many calligraphers emerged, and their scripts can be found on a variety of steles, clocks, and pagodas.

In the eighth century, Kim Saeng became Korea's first famous calligrapher. He learned Chinese calligraphy as a child, and practiced it through to his old age. He had a good command of both the running and official scripts, and could be compared with Wang Xizhi in running and running-cursive handwriting. None of his original works have survived, but his characters have been used in three different kinds of copybook on tablet inscriptions, which represent the earliest calligraphic work found on the Korean peninsula today. Here we can see his running-script version of *Poem on Lushan Waterfall*, originally written by Li Bai of the Tang Dynasty.

Korean calligraphers have long admired the works of Chinese calligraphers. In particular, they have admired the graceful running script and regular script handwriting of Zhao Mengfu of the Yuan Dynasty. In the fourteenth century, Zhao-style characters appeared in official documents and articles by scholars in Korea.

In the seventh century, Chinese calligraphy also reached Japan. In 615, a Japanese prince made a copy of *Explanation of the Lotus Sutra* with a soft writing brush, the earliest handwriting from Japan that exists today. The characters are smooth and harmonious, and look similar to those of a Jin Dynasty script.

The eighth century saw the development of Sino-Japanese cultural exchanges, and Japan sent many diplomats, students and monks to China, who lived there for long periods of time. When they returned to Japan, they took with them many calligraphic works, in particular those by Wang Xizhi and Wang Xianzhi of the Jin Dynasty, and Ouyang Xun and Ya Zhenqing of the Tang Dynasty. A Japanese empress, who studied the style

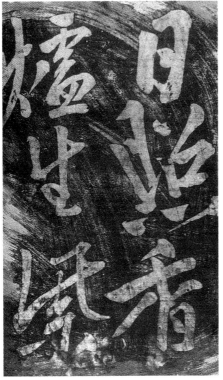

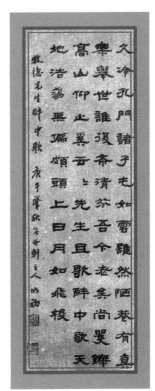

Part of *Poem on Lushan Waterfall*, written in the running script by Kim Saeng of Korea.

Drunken Song, written in the official script by Kim Yeng Hyua of the Republic of Korea.
Kim is a famous calligrapher and seal cutter in the Republic of Korea. Now he is chairman of the Oriental Calligraphy Research Society and the Seal Cutting Society of the ROK.

of Wang Xizhi, became a renowned calligrapher in her own right. In the centuries that followed, works by famous calligraphers of the Song, Yuan, Ming and Qing dynasties were introduced to Japan. In the late nineteenth century, Yang Shoujing, a diplomat from the Qing Dynasty and an expert on bronze and stone inscriptions, took to Japan some copybooks of stone inscriptions from the Northern Wei Dynasty, which influenced the style of Japanese calligraphy.

At the same time, Japanese calligraphers created their own works and styles by combining Chinese styles with their own aesthetics and written language. Since then, Japanese calligraphy has become an art of its own, and is different from that of China. In the ninth century, the kana script appeared in Japan. Most of the letters used in Japanese script are borrowed from the basic structural parts of Chinese characters; the type used in the printing script (or regular script) is called katakana, and the type used in the writing script, with swift and flowing strokes, is called hiragana. This was a departure from the established practice of using just Chinese characters, and led to the exploration of new styles. Later, "calligraphy with few characters emerged," a style in which a piece of work consists of no more than five characters. This kind of calligraphy had been found in China years before, but had rarely been used by Chinese people. After World War II, a "vanguard" calligraphic style appeared in Japan, as a result of the influence of Western fine art, in particular abstract painting.

Chinese calligraphy has also been warmly accepted by Western artists and used in their creations, especially those by painters and sculptors.

Kana
The characters of Japanese, mostly borrowed from Chinese characters. The reason why kana is called "false character" in Chinese is that it refers to its own characters as "true characters." Kana has two typefaces: regular script (katakana) and script (hiragana).

Example of the Japanese "less-word style."

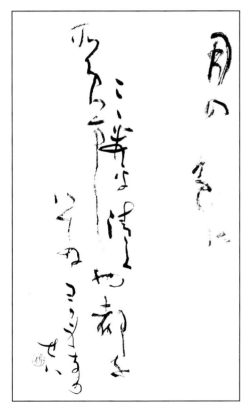

Example of the Japanese "compromising style."

In the early twentieth century, Kandinsky, a German painter and aesthetic theorist, developed the school of abstract painting. He and his counterparts used abstract forms, with dots, lines, surfaces and color, to create striking pictures and express their emotions. They believed that abstract art shared many similarities with Chinese calligraphy, from which they borrowed many ideas. Kandinsky's famous untitled work known as *The First Abstract Watercolor* is composed of shapes and lines, with no center. But the painter demonstrates his ideas through making associations, for example the shapes and lines can be said to look like people in a hurry, or talking at a rural fair; some of the lines look like mountains, and the colors seem to extend beyond the picture frame. The strokes and lines in the picture are powerful, loose, coordinated and dynamic, like a Chinese calligraphic work written in the wild cursive script.

The First Abstract Watercolor by W. Kandinsky.

Paul Klee, a Swiss painter, used patterns, colors and space to express his emotions in his paintings, and he was also good at using musical forms. In these two oil paintings, he uses geometric figures that are reminiscent of the signs carved on ancient Chinese pottery before the development of written Chinese characters.

Sir Herbert Read, a British poet and critic, says in his work on the history of modern painting that abstract expression was an extension of Chinese calligraphy.

Henri Matisse, a leader of the French Impressionist movement, viewed as one of the most important painters of the twentieth century, paid great attention to the simplicity and flow of lines in his work, the inspiration for which he claimed to have taken from Chinese calligraphy.

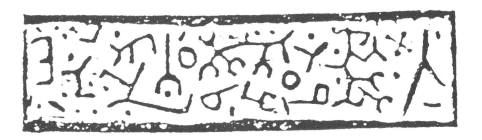

Oil paintings by Paul Klee.

Joan Miró, a Spanish painter and sculptor, is famous for his simple but imaginative paintings. Someone once commented that the space used in his painting is similar to that which appears in Oriental calligraphic works.

Special classes on Chinese calligraphy have been held in many European academies of fine arts, and many global artistic trends and illustrations in books and periodicals have been influenced by Chinese calligraphy.

Calligraphers in China have also drawn upon art from other cultures in recent years. Inspired by Western abstract art and

Signs on ancient pottery before the emergence of Chinese characters.

Japanese calligraphic scripts, a "modern calligraphic style" has been developed, which features strong contrasts between thick and thin strokes, heavy and light ink, dry and wet ink, and the proximity of characters and lines. This new style also uses different colors, and the character patterns have changed and become exaggerated. Some pictographic characters have been created to look like their real shapes, for example in the calligraphic work *Moon and Boat*, the character 月 (moon) in the seal script is like a crescent, while the character 舟 (boat) looks like a real boat on water. The white dots around them look like stars in the sky. Both characters are written in a new style designed to be fresh and eye-catching, and not according to traditional rules regarding the order of the strokes.

Self-Portrait by Joan Miró.

Some modern Chinese calligraphers have boldly taken ideas from the Western abstract and Japanese ink schools, and have used dots, lines and shapes in different colors without making them into characters.

Some people have praised these efforts as breakthroughs and view this as the future direction of Chinese calligraphy, whereas others have criticized it for deviating too far from traditional rules, in particular those works that do not use real Chinese characters. It is unlikely that this debate will reach a conclusion, but perhaps a conclusion is not needed. Those new works that are very creative will form a new trend and add to the many stages in the evolution of Chinese calligraphy.

Moon and Boat by Xu Futong.

It can be argued that Chinese calligraphy is an abstract art in itself, illustrated by the fact that it absorbs the "beauty" of an object; it neatness, balance, symmetry, closeness and looseness, stillness and motion, change and harmony. Chinese calligraphy can also be imitated and reshaped. All of these aspects are similar to Western abstract art, which also creates pictures that are different from the actual objects they represent.

The two arts, however, are also very different. Chinese calligraphy does not imitate other things—instead the characters themselves function as artistic carriers. Western abstract artists, on the other hand, do not use carriers to arrange their lines and colors; they seek unique forms, which have a quite different effect. They focus on the structural and visual effects of their

paintings, particularly their quality and coloring, and try to rebel against tradition and formula. Without the restrictions associated with a carrier, they try to be as creative as possible, producing mysterious, thought-provoking paintings.

Being based on characters, Chinese calligraphy is restricted by rules relating to their structure. All characters apply fixed rules and patterns,

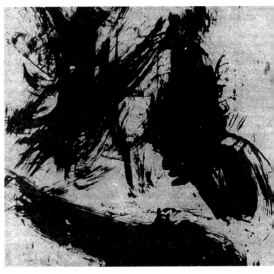

Swimming by Yang Lin.

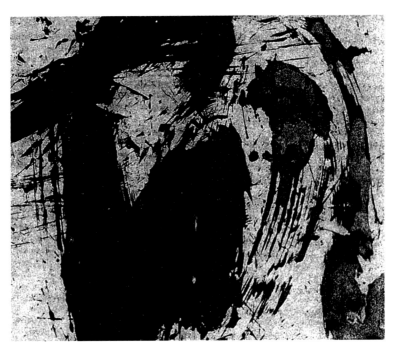

Wind by Yang Lin.

and a set order of strokes. Calligraphers create their works slowly and methodically, and while they may be novel in style and show great variation, the characters are created according to familiar rules, making them readable.

Chinese calligraphers express their emotions through their use of characters. Sun Guoting of the Tang Dynasty said in his *Copybook of Calligraphy* that people create calligraphic works to express what is in their minds, in various possible styles and forms. They follow the principles of structural beauty and nature, and the rules of the objective world. The emotions expressed in calligraphic works are similar to those conveyed through poems in the *Book of Songs* and the *Elegies of Chu*. Peaceful, graceful and natural, they are said to reflect the inner world of the calligrapher.

Appendix:
Chronological Table of the Chinese Dynasties

The Paleolithic Period	c. 1,700,000–10,000 years ago
The Neolithic Period	c. 10,000–4,000 years ago
Xia Dynasty	2070–1600 BC
Shang Dynasty	1600–1046 BC
Western Zhou Dynasty	1046–771 BC
Spring and Autumn Period	770–476 BC
Warring States Period	475–221 BC
Qin Dynasty	221–206 BC
Western Han Dynasty	206 BC–AD 25
Eastern Han Dynasty	25–220
Three Kingdoms	220–280
Western Jin Dynasty	265–317
Eastern Jin Dynasty	317–420
Northern and Southern Dynasties	420–589
Sui Dynasty	581–618
Tang Dynasty	618–907
Five Dynasties	907–960
Northern Song Dynasty	960–1127
Southern Song Dynasty	1127–1276
Yuan Dynasty	1276–1368
Ming Dynasty	1368–1644
Qing Dynasty	1644–1911
Republic of China	1912–1949
People's Republic of China	Founded in 1949